IMAGES
*of America*

# NEW HOPE, LAHASKA, AND BUCKINGHAM

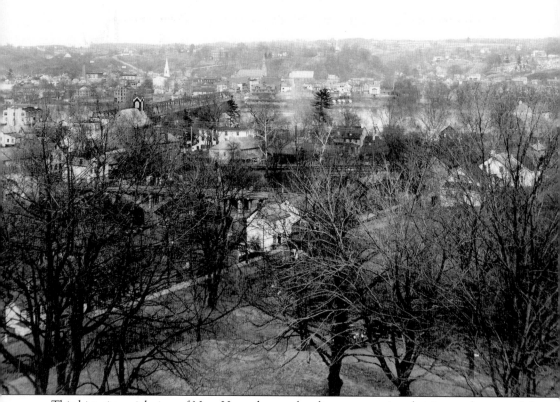

This historic aerial view of New Hope shows a bustling community, thriving at the turn of the 20th century with entrepreneurs, influential families, and artists. It is an oasis nestled in the heart of Bucks County along the Delaware River. Whether a century ago or modern day, the fabric of the community remains the same. (Image courtesy of the New Hope Historical Society.)

IMAGES
*of America*

# NEW HOPE, LAHASKA, AND BUCKINGHAM

Nichole Y. Stella and Jenifer L. Stella

ARCADIA

Copyright © 2005 by Nichole Y. Stella and Jenifer L. Stella
ISBN 0-7385-3796-9

First published 2005

Published by Arcadia Publishing,
Charleston SC, Chicago IL, Portsmouth NH, San Francisco CA

Printed in Great Britain

Library of Congress Catalog Card Number: 2005920264

For all general information, contact Arcadia Publishing:
Telephone 843-853-2070
Fax 843-853-0044
E-mail sales@arcadiapublishing.com
For customer service and orders:
Toll-free 1-888-313-2665

Visit us on the Internet at www.arcadiapublishing.com

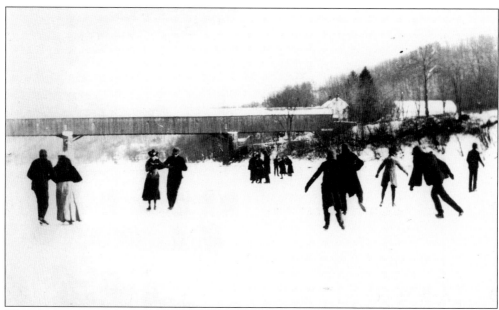

These c. 1900 ice-skaters found fun and frolic on the Delaware River even in the coldest of conditions. This view shows couples gliding together against a backdrop of the historic New Hope covered bridge to Lambertville, which, only a few years later, was destroyed by flood. This image is one of few in existence today showing this beloved covered bridge intact. (Image courtesy of the New Hope Historical Society.)

# CONTENTS

# ACKNOWLEDGMENTS

Without the assistance of some very generous folks this pictorial history of Buckingham, Lahaska, and New Hope, Pennsylvania, would not have been possible. First and foremost, thank you to Frank Quattrone, a fellow Arcadia author, who inspired us to take on this project. Thank you to Anne Richtoric and the staff of the Spruance Library at the Bucks County Historical Society for giving us a great start and invaluable information to get us going. Thank you to Susan Eaton and Les Isbrandt at the New Hope Historical Society for their generosity, time, and wealth of fantastic images. Thank you to Yvonne and Norman Huppertz for their patience in letting us delve into their private collection. Thank you to David Roland and all who helped us at the Old York Road Historical Society. Your images and the map, especially, gave us direction. Also, thank you to Betts Slim and the Buckingham Friends School for your wonderful images, stories, and kind invitation into your school and place of worship. Many thanks to our Arcadia editor Erin Loftus for listening to our ideas and helping to guide us through the process. Last but not least, thank you to our beautiful two-year-old daughter, Jansi, who was incredibly patient and afforded us the time to write a book about one of our favorite family stomping grounds, New Hope.

# INTRODUCTION

*New Hope, PA—Historic Host to the 19th-Century Traveler*
*and the Swift, Sure Coach Line along Old York Road.*

There was one sure way for Colonial settlers as well as Victorian-era city dwellers to get from Philadelphia to New York City. This way was to follow York Road. With a history dating back to 1711, it was the "yellow brick road" of the era and provided travelers with a direct track to the glistening emerald cities of the late 18th century and 19th century.

Until 1845, if a family could not use their personal coach, they could depend on riding the Swift, Sure Coach Line. This coach line, driven by good ole "Yank" Sanford and equipped with four horses, left from the Bailey Sheaf Tavern on Second and Race Streets in Philadelphia at 8:00 a.m. and would arrive at the midway point and tourist stop town of New Hope, Pennsylvania, at 6:00 p.m.

Before arriving at their midway destination, travelers passed through many small towns and villages along the York Road corridor. Nearer their rest stop were the villages of Buckingham and Lahaska. Both towns provided the stage horses a place to stop, rest, and have a bit of water.

The village of Buckingham, comprised almost solely of an elite and wealthy group of English Quakers, also had an elite history with ties to Gen. George Washington and his military battles during the Revolutionary War. It was along the illustrious York Road corridor that his troops traveled. He often stopped at Bogart's Tavern, located at the intersection of York and Durham Roads, the heart and center of Buckingham. Here he consulted with Gen. Nathaniel Greene. Warmed by the hearth's glow from inside the tavern, Greene ordered flatboats to be brought down the river. These boats were for Washington's use in his infamous river crossing, which led to his win at the Battle of Trenton and his eventual strategic victory of the Revolutionary War. In honor of General Greene's order, the tavern was renamed the General Greene Inn.

A traveler's next destination on the Swift, Sure Coach Line was the village of Lahaska, just a few miles north of historic Buckingham. This tiny village was equipped with working lumber mills and a few wagon makers, as well as other peddlers and tradesmen. The community of Buckingham spilled over into Lahaska. Atop a steep hill, aptly named Meeting House Hill, was where the townspeople built their spiritual center, the Buckingham Friends Meeting House. Built in 1830, it was here that the wealthy, well-educated, and liberal-minded families of the community, such as the Fell family, gathered for worship and educated their children. By the mid-19th century the Buckingham Friends would speak out against slavery. Even after the start of the Civil War, community members continued to embrace the philosophy of nonviolence. As they did during Revolutionary War days, the Quaker Friends of Buckingham supported the young men who were injured in battle and converted their meetinghouse into a military hospital to treat those wounded in the increasingly blood-stained war.

There would also be many years of peace and prosperity in the area, and travelers passing through as they made their way along the corridor. Both small villages became tourist stops, where one could have a pint of ale in an "entertainment tavern." Those travelers who were lucky to be high in social ranking would stop and visit the distinguished and notorious Wilkinson family and their favorite son, Col. Elisha Wilkinson. The family were the popular hosts of parties, fox hunts, and other sporting events that were the talk of the town.

After the last party candle was snuffed out, there were still miles to go before weary riders of the Swift, Sure Coach Line put down their bags and finally rested. After traversing close to 40 miles by coach, travelers happened upon a booming river town. It was a natural overnight destination point that eventually would come to be known as New Hope. This developing town began its boom in the summer of 1717. A spirited carpenter named John Wells would be the first to settle here, building his house along the riverside. Many followed his lead and built their homes along this waterfront of industry. Not only homes prospered, but businesses flourished here as well.

With keen business sense, Wells recognized that in order for travelers to continue their trek along the York Road corridor, they needed to get across the Delaware River. In 1722 he established the first ferry to Lambertville, New Jersey. The new ferry attracted flocks of travelers to the town. Wells's ingenuity and quickness to satisfy travelers' needs led him next to build the first inn. With its views of the waterfront, the Ferry Inn (eventually known as the Logan Inn) became the inn of choice. For many years, not only was the inn named after the ferry, but the town, too, was named after the ferry that drove the town's economy and attracted tourists.

A half century passed, and the ferry business changed hands numerous times. Each time the business was sold, the name of the ferry changed, and so too, did the name of the town. It would have no name of distinction until Benjamin Parry arrived on the scene. Parry, one of the community's unluckiest yet most hopeful residents, owned a home and many mills in this river town. In 1790 his mills were destroyed by fire. But Parry, always the optimist, rebuilt his business and named it the New Hope Mills. Over time this too became the inspired and permanent name of the village.

The town, famous for its milling industry, would also become known for the beauty of its surrounding landscapes. The enchanting views attracted a group of artists to the area. William Lathrop and Edward Redfield came to New Hope to paint the views, and in the New Hope area they stayed. These artists, inspired by the French Impressionists, believed that no other place in the region more closely resembled the landscapes that inspired the great European painters than New Hope did. Thus, New Hope's artist colony was born.

Finally the picturesque town was complete. Travelers awoke after a restful night's sleep and explored New Hope. They could discover the town's richness in culture, art, and culinary delights before making their way across the Delaware River and on to New York.

# One
# THE OLD YORK ROAD CORRIDOR

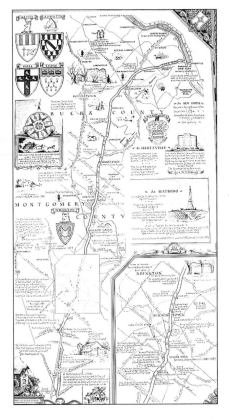

This map, surveyed in 1711, covers approximately 40 miles of terrain along the Old York Road corridor. This route played a vital role in American history, serving as a main artery in connecting the flow of commerce between northeast America's oldest and largest cities—Philadelphia and New York. (Map courtesy of the Old York Road Historical Society.)

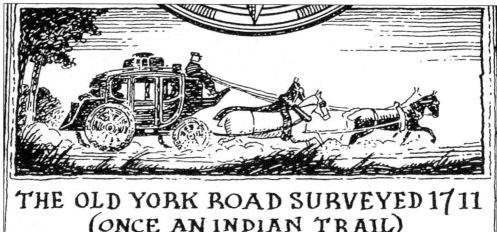

# THE OLD YORK ROAD SURVEYED 1711 (ONCE AN INDIAN TRAIL) WAS STAGE COACH ROUTE BETWEEN PHILADELPHIA and NEW YORK MADE RUN IN 3 DAYS AT 2 PENCE per MILE

Until 1845, if a family could not use a personal coach, like the one above, they could depend on riding the Swift, Sure Coach Line. This coach line, driven by good ole "Yank" Sanford and equipped with four horses, left from the Bailey Sheaf Tavern, on Second and Race Streets in Philadelphia, at 8:00 a.m. and arrived at the midway point and tourist stop town of New Hope, Pennsylvania, at 6:00 p.m. (Image courtesy of the Old York Road Historical Society.)

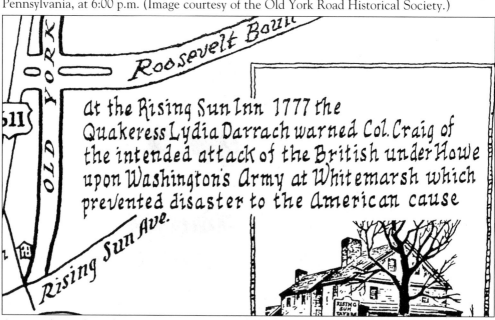

At the Rising Sun Inn 1777 the Quakeress Lydia Darrach warned Col. Craig of the intended attack of the British under Howe upon Washington's Army at Whitemarsh which prevented disaster to the American cause

Among the earliest destinations along the Old York Road corridor was the Old Rising Sun Tavern, located on Rising Sun Avenue in Philadelphia. This location gained infamy in 1777 when Mrs. Lydia Darrach, a local Quaker resident, sought out Col. Thomas Craig at the inn and informed him of the British army's intended attack on George Washington's troops at Whitemarsh, Pennsylvania, just a few miles away. (Image courtesy of the Old York Road Historical Society.)

During the early days of the Swift, Sure Coach Line, the privilege of a three-day journey cost travelers a mere two pence per mile. This image depicts England's King George on the 1749 halfpence. (Reproduced from the original held by the Department of Special Collections of the University Libraries of Notre Dame.)

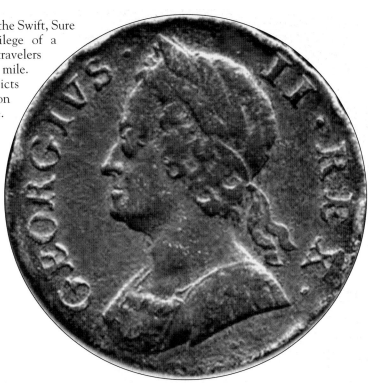

These coins were sent to the Colonies from overseas for use as American currency. It would not be until 1787 that the first one-cent American coin would be struck. (Reproduced from the original held by the Department of Special Collections of the University Libraries of Notre Dame.)

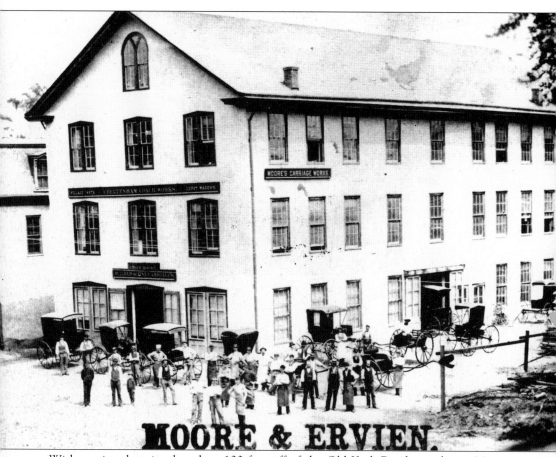

With a prime location less than 100 feet off of the Old York Road corridor in Montgomery County, the well-established coach-making company of Moore & Ervien, partnered in 1882, successfully kept the middle and upper echelons traveling the Old York corridor in style. With 35 hands employed and a payroll of $1,500 a month, the company crafted phaetons, wagons, carriages, and buggies from rough wood beginnings to carriages with fancy upholstery and lavish, hand-painted artwork. (Image courtesy of the Old York Road Historical Society.)

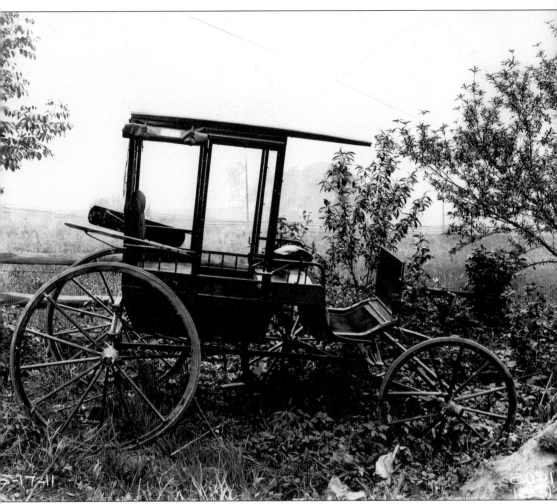

Wealthy families of the era often owned their own horse-drawn carriages. Seen here is a closeup of a buggy that wasn't able to complete the journey. The polite conversations about road and weather had a meaningful place during these times. With harsh roadways, wooden wheels, horses that experienced fatigue, and the threat of inhospitable weather conditions, the journeys were often difficult. (Image courtesy of the Old York Road Historical Society.)

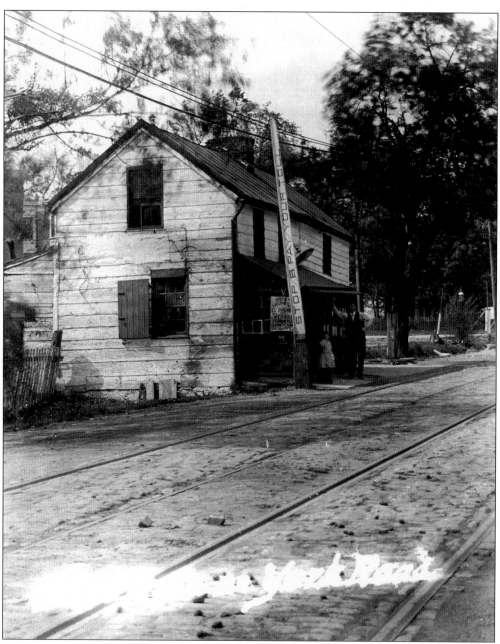

During the early 1800s, tollhouses, like the one pictured above, were erected along the Old York Road corridor. This road originated from old footpaths and evolved into what was advertised by the Swift, Sure Coach Line in the 1840s as being "the safest and most convenient" roadway to travel. When happening upon a tollhouse, travelers could expect to pay tolls that varied from locale to locale. Examples of such tolls were as follows: sled and horse, 3¢; horse and rider, 4¢; and stagecoach with two horses and four wheels, 12¢. (Image courtesy of the Old York Road Historical Society.)

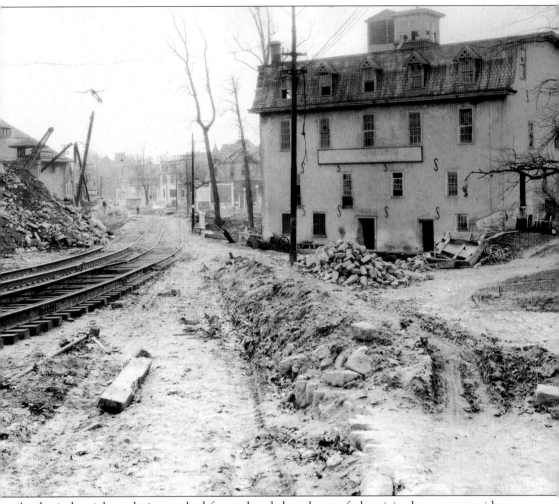

As the industrial revolution pushed forward and the advent of electricity began to provide a more reliable power source, reliance on water power and the milling industry began to deteriorate. This image provides an example of the changes that occurred as horsepower was shifted from the horse and buggy to the electrically powered trolley. These tracks, pictured in their infancy, would mature and give travelers a speedier method of transportation. (Image courtesy of the Old York Road Historical Society.)

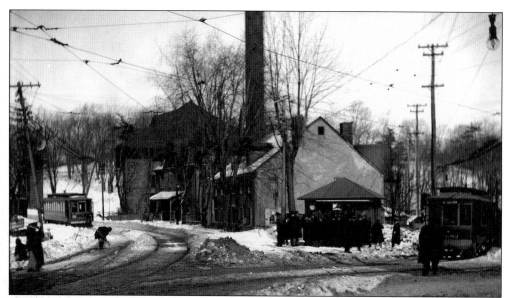

This view pictures a fully functional electric trolley system in the early 20th century. Up until this point, the tried-and-true horse-and-buggy system had not been threatened. Now, as public transportation became more reliable and readily available, even in the suburbs, locals saw the landscape of their towns change along with the transition from the clickity clack of horse's hooves to the buzz of the electric trolley. (Image courtesy of the Old York Road Historical Society.)

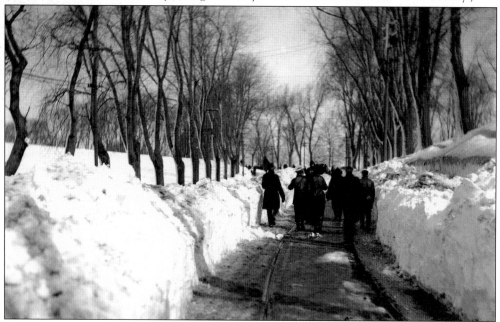

Regardless of how advanced transportation systems became, Mother Nature was still in charge of the roadways. As shown in this image, those who became reliant on the trolley system would certainly be waylaid on this day while trying to make their way along the corridor. Under conditions like these, a horse-drawn sleigh would not only be nostalgic, but would also allow a traveler to arrive at his destination on schedule. (Image courtesy of the Old York Road Historical Society.)

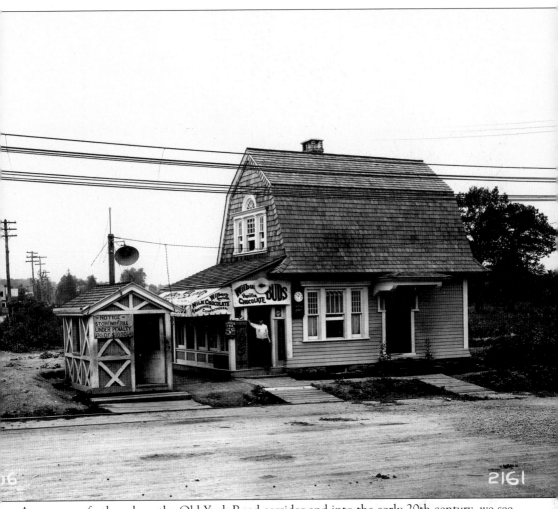

As we move further along the Old York Road corridor and into the early 20th century, we see tollhouses still in use; not only do they collect monies, but they also cater to the needs of the emerging motorists in some of the earliest automobiles of the day. These tourists have hit the road in exploration and found many new restaurants, inns, and resting stops that have been erected as the population and consumerism flourishes. (Image courtesy of the Old York Road Historical Society.)

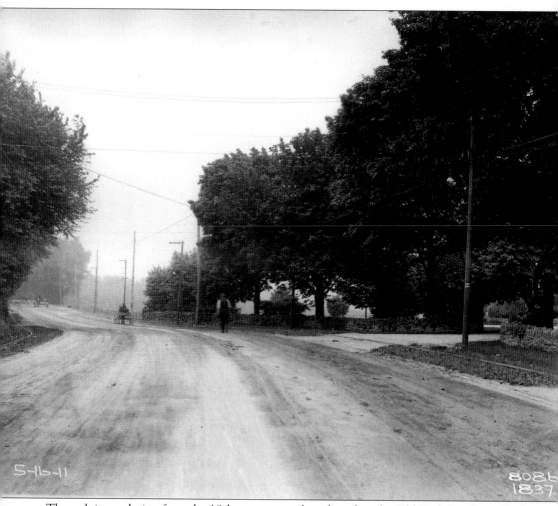

Through its evolution from the 18th century until modern day, the Old York Road corridor has proven to be an invaluable thoroughfare to those who live along the route and to those who travel along it as well. It is a true symbol of Americana, providing safe passage for soldiers fighting for freedom as well as weary travelers, while also giving opportunity to those with an entrepreneurial spirit. This view shows the corridor extending off into agricultural lands and deeper into our journey to historic New Hope, Pennsylvania. (Image courtesy of the Old York Road Historical Society.)

# Two

# BUCKINGHAM AND LAHASKA

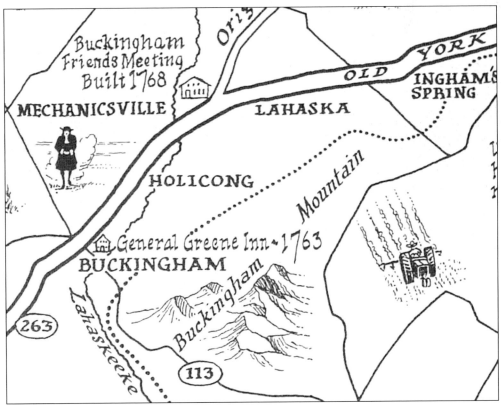

Before arriving at their midway destination of New Hope, travelers passed through many small towns and villages along the York Road corridor. Nearer to their rest stop were the villages of Buckingham and Lahaska. Both towns provided a place where stage horses could stop, rest, and have a bit of water. (Map courtesy of the Old York Road Historical Society.)

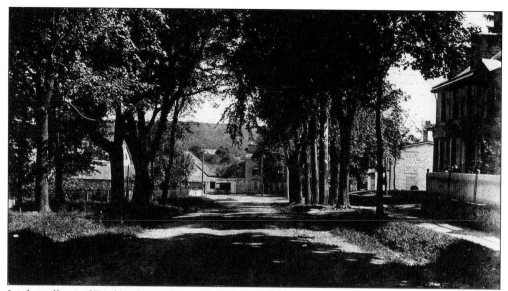

In the village of Buckingham, the well-traveled York Road intersected with the local Durham Road and Doylestown Road. This intersection was known as a main junction and the heart of the village in this prosperous little town. The junction area became a tapestry combining both the socially elite villagers and travelers alike. This portion of the Old York Road corridor would be the eventual home of an inn built upon a foundation of great American history during the Revolutionary War. (Image courtesy of the Bucks County Historical Society.)

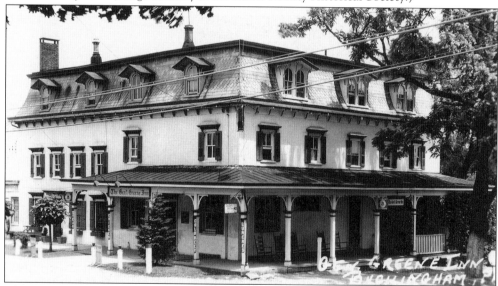

This is an early-1900s view of the General Greene Inn. Henry Jamison established the inn in June 1752. After his death, his wife, Mary Jamison became the popular hostess of the inn. In 1772 she married John Bogart, and the inn was thus named Bogart's Tavern. It was here General Greene consulted with Gen. George Washington. This tavern became Greene's headquarters in the winter of 1776. During his stay at the inn, General Greene gave the historically noted order to bring down the boats, a move that enabled the Americans to win the Battle of Trenton and, eventually, the war. (Image courtesy of the Bucks County Historical Society.)

Gen. Nathaniel Greene was the decorated commander of General Washington's left wing at the Battle of Trenton. In the early days of December 1776, General Greene ordered 16 flatboats to be brought down the Delaware River for Washington's use in his infamous crossing. At the suggestion of Col. Henry Paxson, as a show of appreciation, it was declared that Bogart's Tavern—where Greene set up his headquarters—be renamed the General Greene Inn. The name remains today.

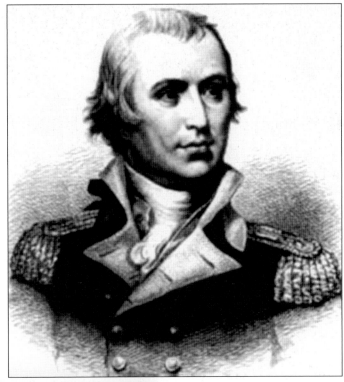

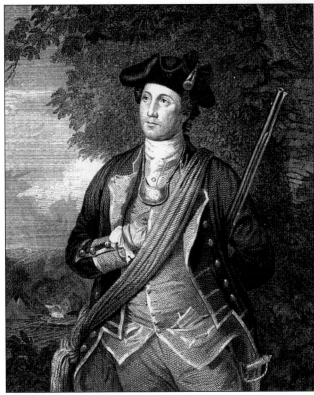

George Washington was born on February 22, 1732, in Westmoreland, Virginia. At the height of his military career, he was elected commander in chief of the Continental Army on July 3, 1775. With a clear goal in mind—liberation from Britain—Washington led his inexperienced troops to victory over a six-year period of war. Through his successful campaign he won the respect of the young nation and became its first elected president in 1789, and remained in office through 1797.

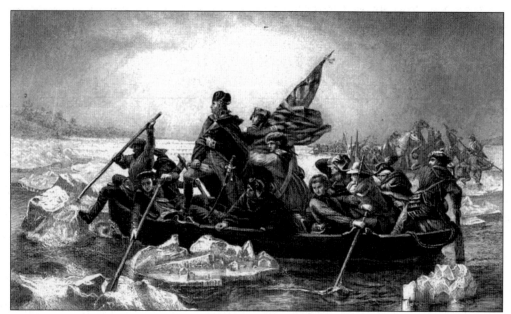

Above is artist E. Leutze's depiction of Washington's famous crossing of the Delaware River in December 1776. This is one of the most recognizable images from American history. It was in New Hope, Bucks County, on the Delaware River, and not far off of the Old York Road corridor, that this historic event took place.

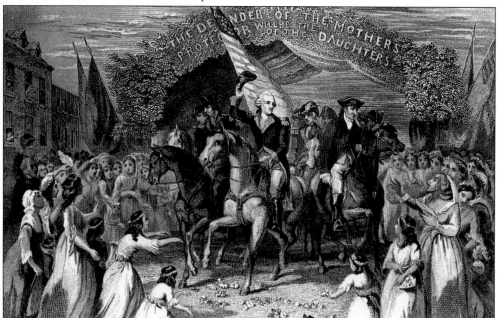

This image depicts a heroic General Washington, taking a congratulatory ride through the streets of Trenton. It was upon General Greene's command that all boats be moved to the west bank of the Delaware River, effectively trapping the British and leaving them without the ability to cross. The Continental Army, with all boats being heavily guarded, waited along the riverside from Dunks to Coryell's Ferry in New Hope. Eventually these boats would be used to cross the Delaware and defeat the British at the Battle of Trenton.

This 19th-century Buckingham/Lahaska craftsman, identified by his family name, Funk, was a specialized wagon builder. This was just one of the many industries that boomed in this logging and milling community, where wagons were not a luxury but a necessity. The wagon pictured here is a work in progress. (Image courtesy of the Bucks County Historical Society.)

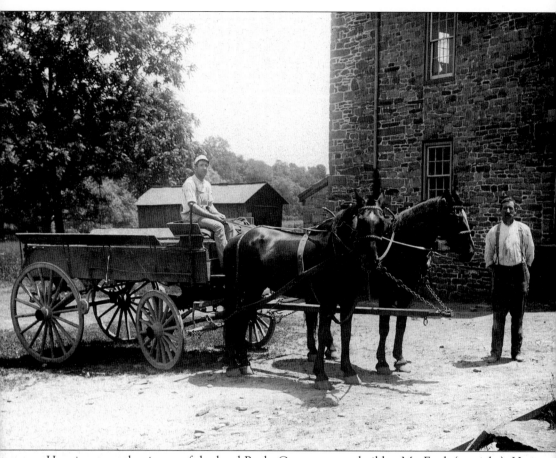

Here is yet another image of the local Bucks County wagon builder, Mr. Funk (on right). He is pictured with an apprentice and two strong and sturdy horses set to pull his glistening new final product. Among Funk's many customers were local lumber and flour millers who needed wagons to transport their valuable cargo. (Image courtesy of the Bucks County Historical Society.)

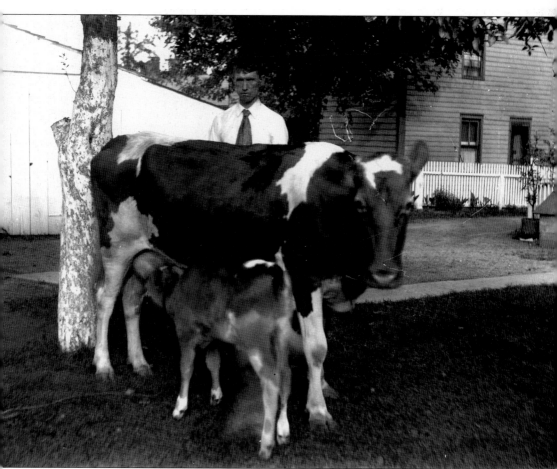

Agriculture and dairy farming was a major industry of the day and the region. Buckingham, with its rolling hills and pastures, offered even farm animals a picturesque view of life. This young man stands proudly outside his home with his cow and her calf. This c. 1900 photograph is a rare image indeed of a calf drinking milk from its mother. (Image courtesy of the New Hope Historical Society.)

Pictured here are two 19th-century mill views. Above is an unidentified mill, surrounded by the beautiful rolling landscapes that this area is known for. Along with agriculture, craft trades, and small-store ownership, milling of lumber, grain, and flour were among the major industries in the area during this time. Below is the Vandegrift lumber mill. The wealthy and respected Vandegrift family of Buckingham owned and operated this mill. (Top image courtesy of the New Hope Historical Society; bottom image courtesy of the Bucks County Historical Society.)

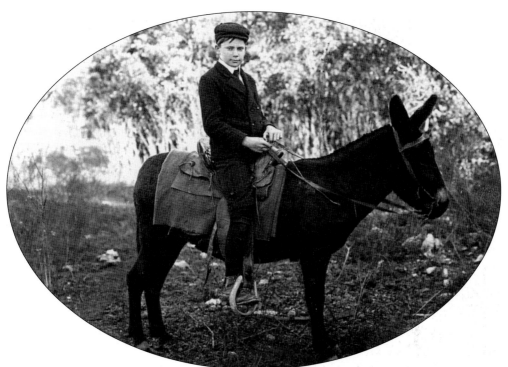

These images are 19th-century portraits of Buckingham children enjoying the prosperity of an agricultural life. In this era it was a sign of wealth and status to be able to afford having a portrait taken, especially one with a family pet. The young boy above attempts a dapper smile for the camera while riding his mule, while the young toddler at right sits atop her paint pony. (Images from the collection of Norman and Yvonne Huppertz.)

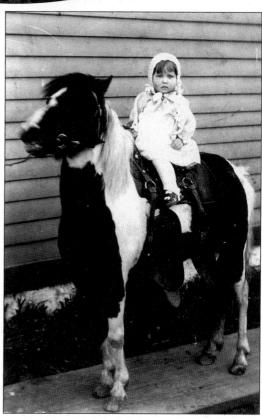

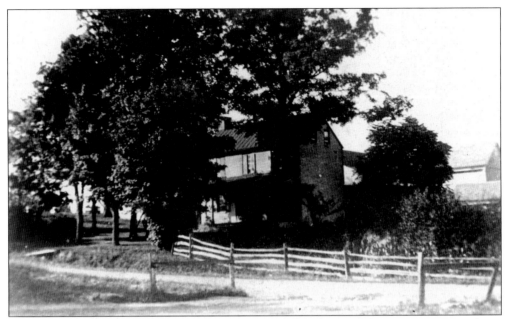

Throughout the 19th century, the family of Henry Fell had one of the most prestigious farms and seed businesses in the region. Their prosperity was reflective of the location. With the rich soil and plentiful water resources, Buckingham and Lahaska bore many successful farming and milling families. The Fells were indicative of families living on this rich and forgiving land. (Image courtesy of the Bucks County Historical Society.)

Among the neighboring farms, the Atkinson family shared in this prosperity. Not only was the land rich and fruitful, but the community was spiritually rich as well. With a growing Quaker community, both the Fells and the Atkinsons were members of the Buckingham Friends as well as teachers at the school. (Image courtesy of the Bucks County Historical Society.)

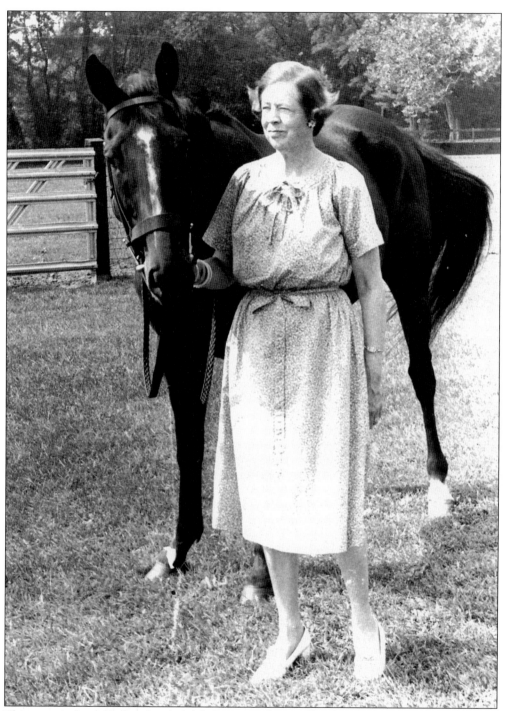

This portrait shows Buckingham's Adele Paxson with one of her horses. She was an accomplished thoroughbred horse breeder, and her family's ties extend deep into the history of the region. A chestnut tree that was on the Paxson family farm was used as a meeting place for generals in the Continental Army. Jane Paxson, an ancestor of Adele, married one of the founding fathers of New Hope, Benjamin Parry. (Image courtesy of the New Hope Historical Society.)

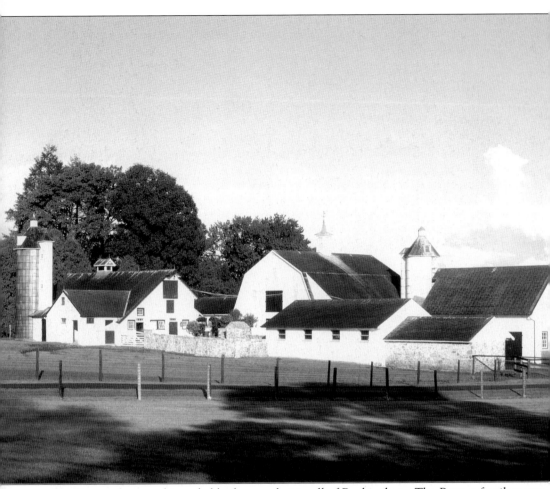

The Paxson farmstead is probably the grandest in all of Buckingham. The Paxson family name is an anchor for this community and reaches back beyond the Revolutionary War period. (Image courtesy of Ron Saari.)

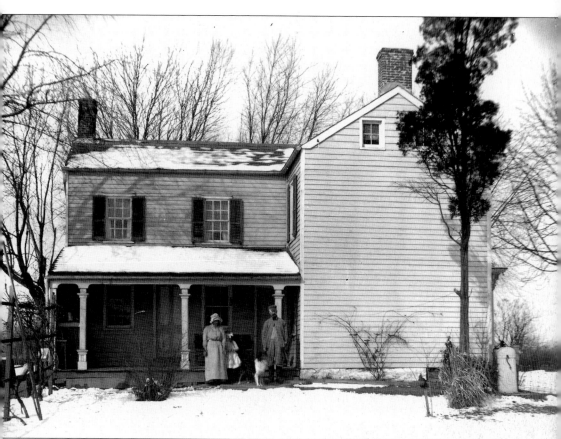

This image shows an everyday family of the early 1900s outside their home on the family farm. It is a blustery and cold Bucks County day. Snow covers the fields as well as the roof of the home. The family, including even their dog, appear to be ready for work. (Image courtesy of the New Hope Historical Society.)

This *c.* 1870s tintype image of three men reveals the artistry and showmanship of the photographic age coming into its own. This Buckingham trio is enjoying a wonderful summer afternoon, frolicking and posing for the camera. The gentleman on the far right holds a watermelon rind in hand.

In keeping with the summer theme, this image portrays a well-to-do *c.* 1870s Buckingham family in their swimming attire, poised to hit the Delaware River for a splashing good time. It is not a rare sight to see area folk lazily waste the day away under the hot summer sun. It is, however, extraordinary to see a family of this era go to the expense of having their portrait taken in their swimwear. (Image from the collection of Norman and Yvonne Huppertz.)

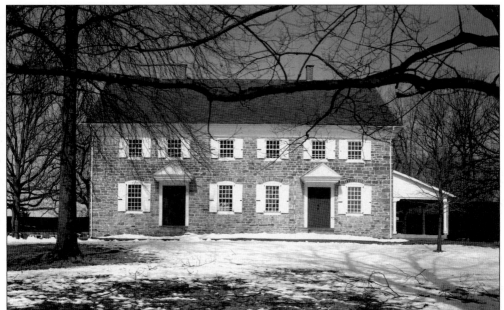

The stone-and-slate Buckingham Friends Meeting House was originally built by master builder Mathias Hutchinson in 1768. Even today it retains its original hand-blown glass windowpanes and hand-hewn benches. From its steep view atop Meeting House Hill in Lahaska, the meetinghouse looks down upon the village of Buckingham and the homes of the many villagers whose families have worshiped inside its walls for generations. Founded in part by the forward-thinking Fox and Fell families during both the Revolutionary and Civil Wars, the Friends Meeting House served as a military hospital to the many who were injured in battle. Although the Quaker community was against war, its members felt a moral obligation to help others find religious freedom in the New World and later sided firmly with the abolitionist movement to end slavery. (Images courtesy of the Buckingham Friends School.)

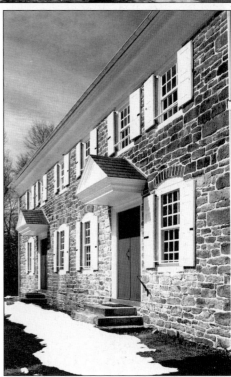

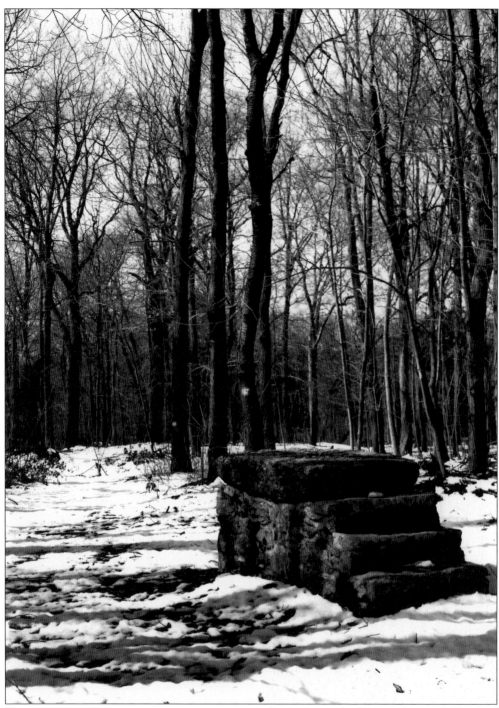

When carriages, buggies, and coaches veered off Old York Road and onto the grounds of the Buckingham Friends Meeting House, their horses would be led up a gentle incline to a set of hand-laid stone stairs. The steps were used to assist the passengers in dismounting from the carriages and coaches. The stairs still stand on the property today. (Image courtesy of the Buckingham Friends School.)

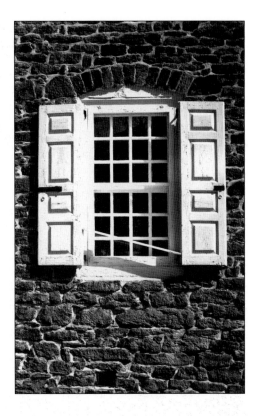

Early architectural features such as interior-locking doors and hand-forged locking mechanisms on exterior window shutters help to illustrate that religious freedom did not come without a price. Though the Quaker Friends of Buckingham did not believe in violence themselves, the 18th-century religious group had to battle intolerance. The sanctity and privacy of the meeting was ensured by the devices seen at right and below. (Images courtesy of the Buckingham Friends School.)

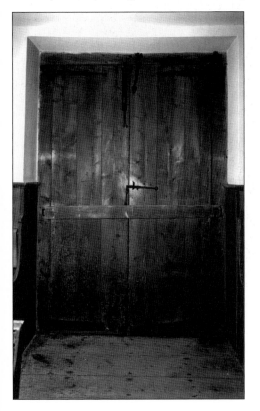

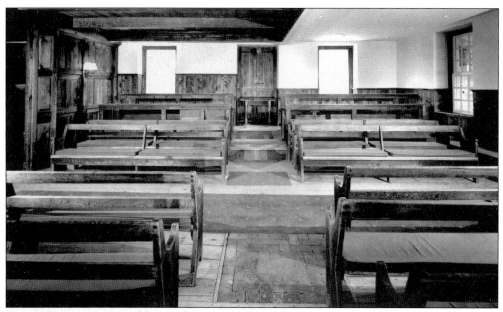

This interior view shows the double meetinghouse layout that became a model for Friends meetinghouses throughout the country. Following the liberal-minded leadership of George Fox and his wife, Margaret Fell, the Buckingham Friends forged far ahead of their time, pushing for equality of the sexes. This "double" layout gave space to both male and female Society members. (Image courtesy of the Buckingham Friends School.)

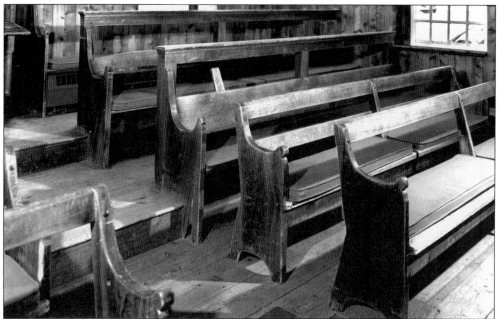

These images depict the modest interior of the Buckingham Friends Meeting House. On a typical Sunday morning, the Friends would gather for a meeting that lasted about one hour. In this time they would fill these benches with reverent silence and expectant waiting. Unlike conventional worship, these meetings were usually not led by a pastor. Members were, and still are, free to share a message with the assembly at any time. (Image courtesy of the Buckingham Friends School.)

During the 18th and 19th centuries, homes and churches were heated by wood-burning cast-iron stoves. This image shows the beautiful handcrafted cast-iron stove that, for more than a century, heated the Buckingham Friends Meeting House. Because of the Friends' great pride and care for their history, this stove, as with most of the other early architectural features, still stands today. (Image courtesy of the Buckingham Friends School.)

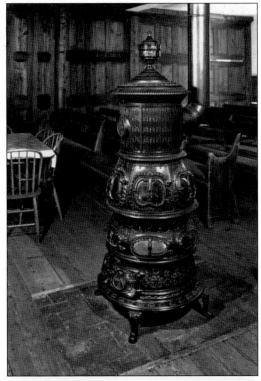

Early-American history is layered with the presence of the Buckingham Friends. Quakers, who hold a firm belief in peace and nonviolence, were still subjected to the violence of the Revolutionary War. As seen in the above image, a bullet entered through a window of the Buckingham Friends Meeting House and left an indelible impression. The Friends did their share to help in the healing of the wounded soldiers by erecting a hospital inside their meetinghouse.

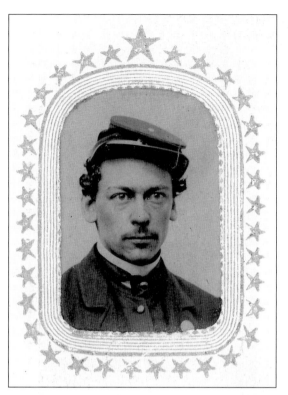

With the nation's independence well established, the issues of personal freedom and slavery would be addressed by a growing nation in the 19th century. Taking a firm stance on the side of the abolitionists, the Buckingham Friends Quaker community worked tirelessly to help in the fight against slavery. In the 1860s the meetinghouse would again serve as a hospital for those wounded in battle. Pictured are two of the region's unidentified Union soldiers.(Images from the collection of Norman and Yvonne Huppertz.)

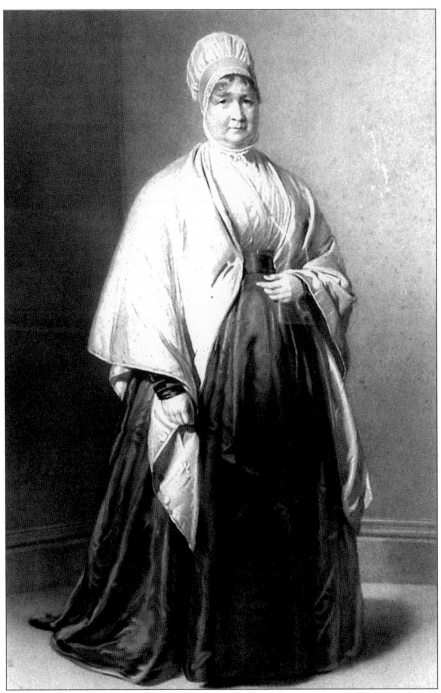

A hero to the Quaker Friends of Buckingham, and to all Friends, is Elizabeth Fry. Born in 18th-century England, she fought for change and humanity in the prison systems. In England during this era, Quakers were imprisoned for their religious beliefs and knew firsthand the horrors of prison life. Elizabeth Fry was a strong voice for change when women weren't allowed a voice at all. She remains a hero to the Quaker community today. (Image courtesy of the Buckingham Friends School.)

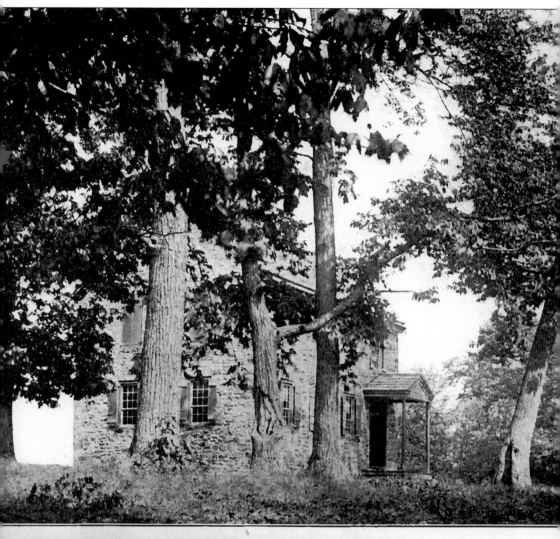

## THE SCHOOL HOUSE

Also constructed by master builder Mathias Hutchinson and skilled carpenter Edward Good was the Buckingham Friends School House. Built from stone that was native to the area and white cedar wood, the school was completed and ready to educate the Friends youth community in 1794. With an educational philosophy that dated back to William Penn, the Quaker community was committed to educating the youth of the village. (Image courtesy of the Buckingham Friends School.)

Lizzie White 1862
Hettie S Williams 1864
Addie Herring 1864
Debbie A Morris 1864-5-
Mary E Corson 1865-6
School closed for repairs
John Baely Carpenter
Annie Cadwalader 1867-68
Lidie M Ely 1869
Mattie Fell 1869-70-71-72
Anna Eliza Smith 4 mo in Sickness
Joseph J Broadhurst 1872-73
Debbie B Smith 1873-74
Minnie Moon 1875-76-77-78
Elizabeth Loyd 1879-80-81-82-83
Cynthia Doan 1884-85-
Bell Vansant 1886-87-88-89
Anna Scarborough 88-90-91-92-93
Anna Brinton 94-95-

Pictured is a teacher list from the Buckingham Friends School. It includes teacher names and the years when they taught classes, dating as far back as the 1820s. Throughout the list are notable family surnames from the Buckingham, Lahaska, and New Hope communities, such as Fell, Atkinson, Smith, Paxson, Michener, and Parry. (Images courtesy of the Buckingham Friends School.)

Elizabeth Eisenbrey.
Deborah Smith
William H. Johnson 1851.
Sarah Elizabeth Fell.
Susan Parry until 1847.
Albert S. Paxson 1847
Ezra Michener.

M Ellen Atkinson 1895 & 1896.
Lettie H Bells 1896-97 &
Chas. S. Gordon 98 & 99
Ellen D. Ley 99-00-01
Louisa H. Burril 58 & 59

Passmore Betts 54.
Harry ...

Charles Walton
Joseph Fell ... 1827 (4 mo. 10th)
" " " 1828 (4 mo 8th)
" " " 1829 (2 mo 16th)

First minutes recorded in book dated
21st of 2nd mo. 1875 Minnie Moon teacher

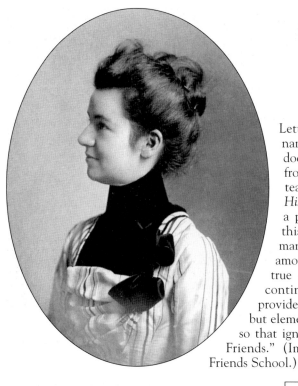

Lettie K. Betts (who is among those named on the previous teacher list) was documented to have taught at the school from 1896 through 1898. Along with teaching at the school, she also wrote *History of the Buckingham Friends School*, a portion of which is shown below. In this account she writes, "There were many highly educated men and women among the early settlers, as is especially true of Solebury and Buckingham." She continued, "No Friends colleges were provided until the middle of the 19th century, but elementary education was never neglected, so that ignorance and poverty were rare among Friends." (Images courtesy of the Buckingham Friends School.)

### HISTORY OF BUCKINGHAM FRIENDS' SCHOOL

LETTIE K. BETTS

When William Penn began his "holy experiment" he laid great stress on education as a preparation for life work. Being a man of wide education himself, he knew the value of it, but he realized that such an education as he himself had would not be a preparation for life in a new country. So he planned that every child over twelve years of age should be taught a useful trade. What a pity this was not carried out! We might not now have to be grappling with the idea of vocational guidance!

The early Friends had the true vision. Unfortunately, life in Pennsylvania did not demand deep learning, but there were many highly educated men and women among the early settlers, as is especially true of Solebury and Buckingham. It is not our purpose to make illustrations in this paper. College training was no longer essential, and no Friends' colleges were provided until the middle of the nineteenth century, but elementary education was never neglected, so that ignorance and poverty were rare among Friends.

The Yearly Meeting at Philadelphia had a concern for the education of all her children and periodically issued advices to the Monthly Meetings. I would recommend these to your perusal, for they are applicable to modern pedagogy. To carry out these ideals the members of the local meetings raised subscription funds as their circumstances permitted. Buckingham Friends recognized their obligations and made provisions in their wills for bequests to the cause of education. The first of these to Buckingham was by Adam Harker, account of which appears on the Monthly Meeting minutes of Fifth Month 5th, 1755, in which he gives "to Israel Pemberton, Jr., and John Smith, of Philadelphia, Thomas Smith and Joseph Watson, of Buckingham, £40 lawful money upon special trust and confidence that they shall and will therewith purchase an annuity or ground rent, or in such manner as they may think proper, employ the said sum towards raising a fund for settling or maintaining a free school in Buckingham, aforesaid, under the care and direction of the Monthly Meeting of Friends here." It is further provided that the trust shall pass to executors or administrators of the men named or the survivors thereof.

He also left legacies to Middletown and Wrightstown, but for

30

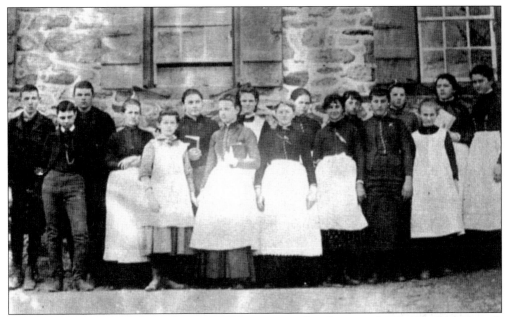

Shown above is one of the earliest remaining images of students at the Buckingham Friends School. This class picture from 1881 shows students in the traditional slate-colored dress. (Image courtesy of the Buckingham Friends School.)

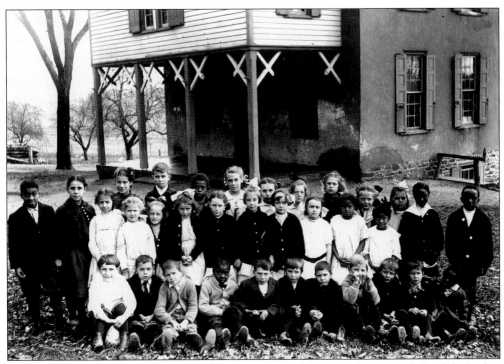

At a time when the nation was torn and segregation was the norm, the primarily English Quaker communities of Buckingham and Lahaska were diverse and accepting of African American families in their community and school. (Image courtesy of the Bucks County Historical Society.)

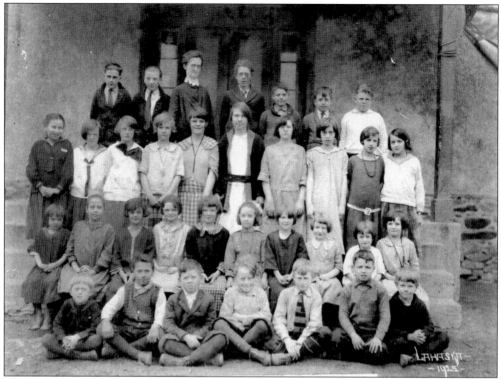

Photographed in the 1920s, these sweet and youthful faces are indicative of the time. No longer in drab dress, the students are smiling, the girls in their flapper-style dresses and the boys in their knickers and ties. (Image courtesy of the Buckingham Friends School.)

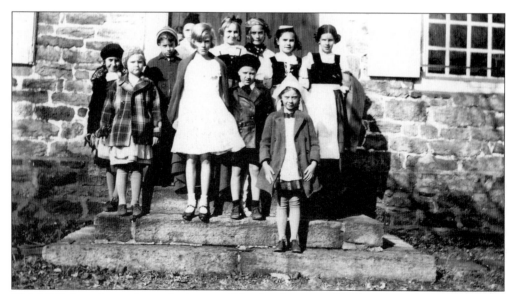

This 1936 class picture shows the impact of the development of public schools coupled with the hard times of the Depression era. Buckingham Friends School enrollment was at an all-time low, with only 11 students.

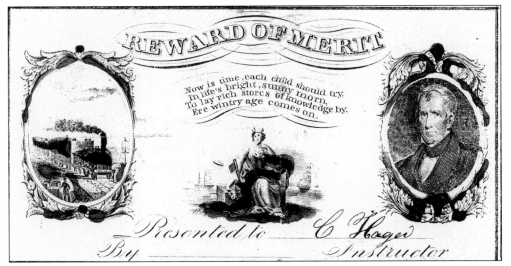

Pictured is an elaborate and beautifully handcrafted school certificate of accomplishment. These were given to students who completed a job with excellence. The inscription reads: "Now is time, each child should try, / In life's bright, sunny morn, / To lay rich stores of knowledge by, / Ere wintry age comes on." (Image from the collection of Norman and Yvonne Huppertz.)

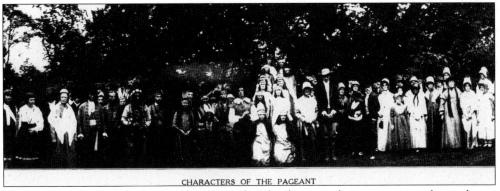

Each year, students at the Buckingham Friends School put on their costumes and staged on a show. This is an early-20th-century image of students who played parts in the pageant. (Image courtesy of the Buckingham Friends School.)

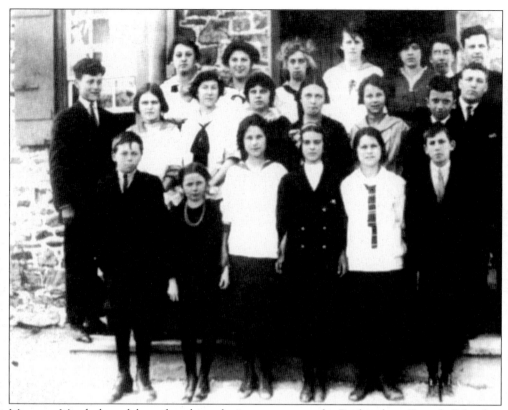

Margaret Mead, the celebrated anthropologist, was sent to the Buckingham Friends School in 1911 when she was 11 years old. Having previously been educated at home by her grandmother, Mead's family decided it was time for her to receive a more formal education. When Mead first arrived at school, it was during hard times. There was only funding for one teacher for three grade levels. Regardless, Mead's family believed the "famous old foundation" that educated a number of chief justices of the Pennsylvania courts would be the place for their daughter to flourish, and flourish she did. (Image courtesy of the Buckingham Friends School.)

The Quaker-educated Margaret Mead, cultural anthropologist, is best known for her studies of Samoan tribes and her book, *Coming of Age in Samoa*. Mead died in 1978 and is buried in the Buckingham Friends graveyard. Always rooted in her Quaker optimism, she is remembered as saying: "Never doubt that a small group of thoughtful, committed people can change the world. Indeed it is the only thing that ever has."

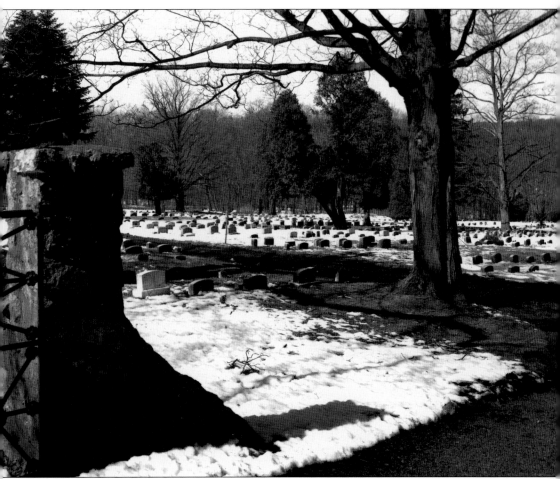

This view shows the entryway to the Buckingham Friends Graveyard, located directly behind the meetinghouse. It is here that founding families and Society members lay in rest. (Image courtesy of the Buckingham Friends School.)

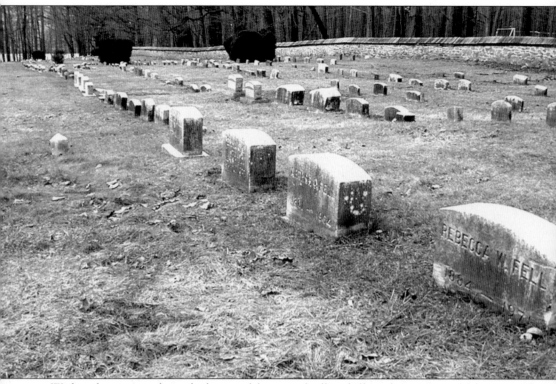

Within the graveyard one finds peaceful views of rolling hills and sunsets on the horizon. The founding families, such as the Fells, had a deep commitment and spiritual connection to the land atop the hill that afforded them their religious freedom. They lived a Quaker way of life and rest in the comfort of the legacy of the Friends.

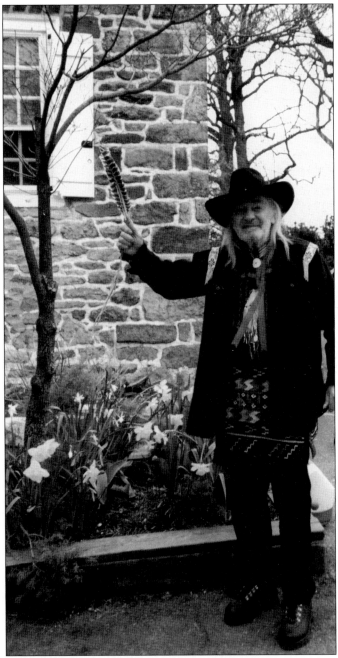

Pictured is Ed Fell, a 1934 graduate of Buckingham Friends School. Born of Native American blood, Ed was adopted into the Fell family. In the true Quaker tradition of recognizing individuality and cultural diversity, the adoptive Fell parents allowed young Ed to keep with his heritage. Upon discovering his discomfort in sleeping under the Fell family roof, the parents permitted Ed to set up a tepee in the backyard, where he would sleep each night. This photograph shows Ed Fell as an adult returning to the Quaker school. At this reunion he pitched a tent on school grounds and shared his story and culture with current students. (Image courtesy of the Buckingham Friends School.)

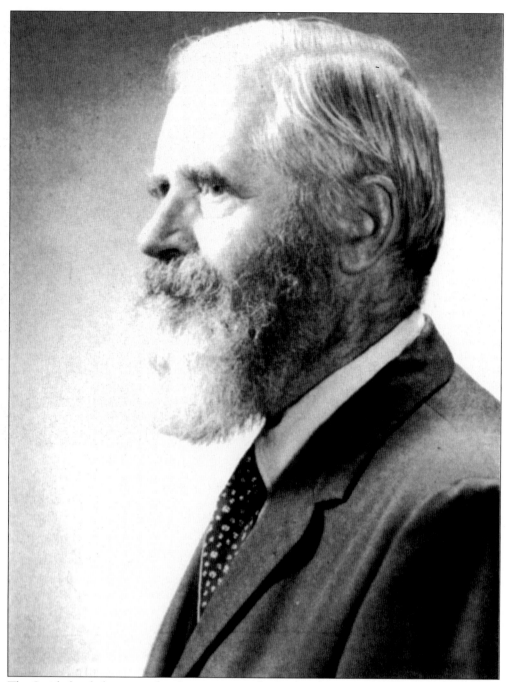

The Smith family lineage is deeply woven into the Buckingham Society of Friends. Pictured is James Iden Smith, who with his brother, Philip, worked diligently as dairy farmers. They were deeply committed to the cause of peace and equality. Philip and James traveled to Russia to teach modern farming methods and in later years traveled back as part of a peace delegation. James served on the Buckingham school committee for 44 years. (Image courtesy of the Buckingham Friends School.)

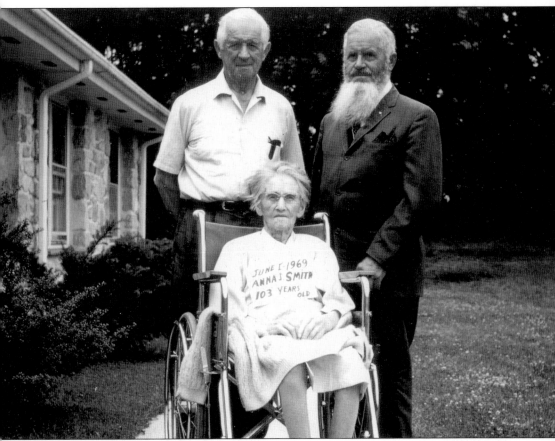

Philip W. Smith (left), Anna Johnson Smith, and James I. Smith are pictured here. This photograph was taken in 1969, when Anna was 103 years old, James was 83, and Philip was 81. Anna, a member of the Friends since its founding, was known to work on quilts and other handcrafted items for the meetings. She was also an avid gardener. Her sons, Philip and James, were both dairy farmers. In the later portion of their lives, the brothers were deeply devoted to the cause of equality, peace, and disarmament. Much to their families' concern, they journeyed south to work for civil rights in the 1960s, protested the Vietnam War, and stood "vigil" at the chemical weapons facility in Maryland. (Image courtesy of the Buckingham Friends School.)

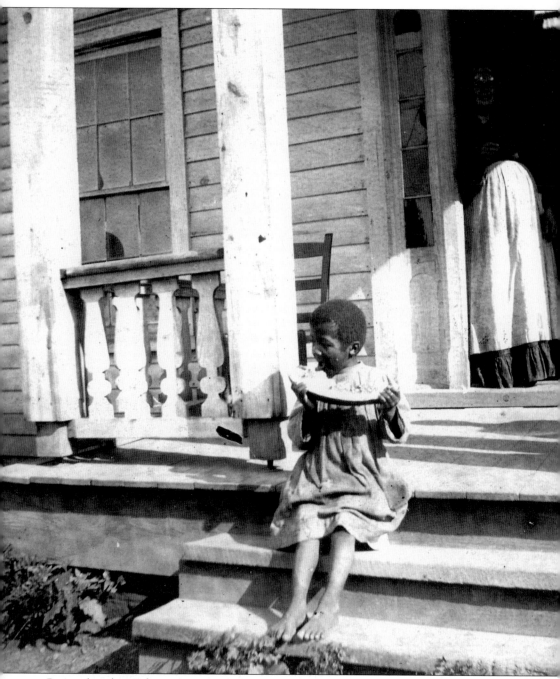

Pictured in this 19th-century view is a happy little girl sitting on her front steps. The people of the villages of Lahaska and Buckingham, particularly the Society of Friends, were welcoming and supportive of the African American community. (Image from the collection of Norman and Yvonne Huppertz.)

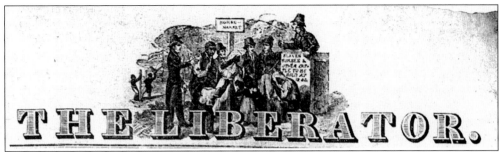

Newspapers such as this one cropped up across abolitionist communities during the 1830s through the 1860s. *The Liberator* was published in Boston by Quaker William Lloyd Garrison and called for "the immediate and complete emancipation of all slaves." The paper had a far reach, and residents of the Philadelphia/Bucks County area contributed financially to Garrison's paper.

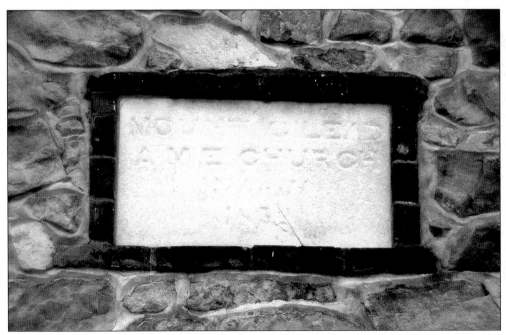

Pictured is a plaque at the Mount Gilead African Methodist Episcopal (AME) Church. It was an African American church built by a runaway slave with the help of the Buckingham Friends. It dates back to 1835. The church, originally built of logs, is now a two-story fieldstone building and historic site.

The Mount Gilead AME Church stands among a grove of trees high atop Buckingham Mountain. The Quaker community, who strongly supported the abolitionist movement and worked to end slavery in the 1800s, helped to establish this church for the early African American community. This church was the last stop on the Underground Railroad in Pennsylvania. Fugitive slaves found freedom by traveling from Buckingham through New Hope and across the Delaware River into New Jersey.

This is the graveyard that lies next to Mount Gilead AME Church. It sits above the villages of Buckingham and Lahaska. This was one of the few safe burial grounds for African Americans during the abolitionist/Civil War era. Although the region was known for its residents' passionate work to end slavery, it did have some blemishes on its record. Native Americans and African Americans were enslaved in the area during the late 1600s and throughout the 1700s.

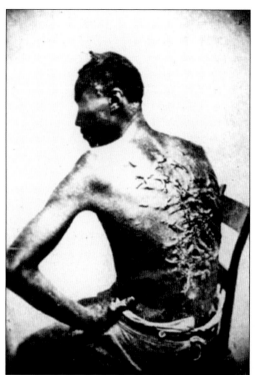

"Overseer Artayou Carrier whipped me. I was two months in bed sore from the whipping. My master come after I was whipped, he discharged the overseer." These are the very words of poor Peter, recorded as he sat for his picture in Baton Rouge, Louisiana, on April 2, 1863. Because of these horrors, churches that existed along the Underground Railroad, like Mount Gilead, were the lifelines for fugitive slaves on the run for freedom. (Image courtesy of National Archives and Records Administration.)

This headstone of Lucy Lloyd doesn't afford much information about who she was. All too often slaves did not have their histories recorded. Although their stories remain largely unknown, the impressions that these lives left on the community and American history can never be diminished. With the help of the Quaker Friends in the 1780s, the act of obtaining new slaves was abolished in the state of Pennsylvania.

Above is a sweet toddler playing with his toy drum c. 1860. Notice his button-up booties and velvet jacket. He was the picture of style for the day. Around his neck is a string-tension snare drum, similar (although much smaller) to the drums Civil War soldiers played when going into battle. (Image from the collection of Nichole and Jenifer Stella.)

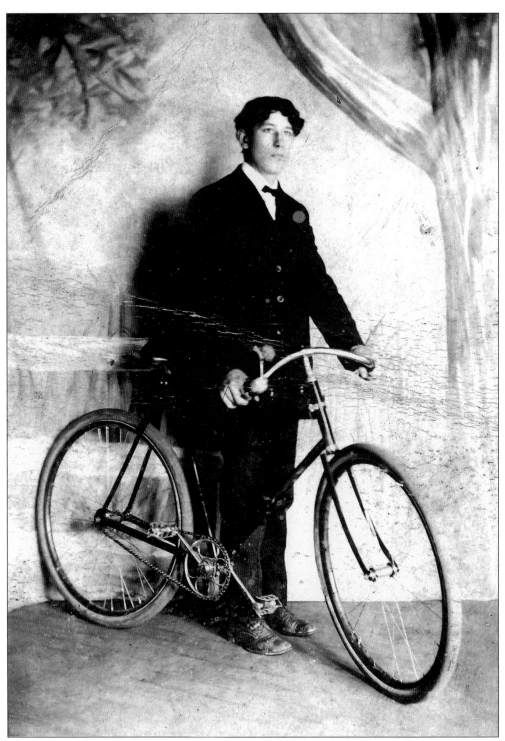

This portrait shows a young Bucks County man with his velocipede or "fast foot" bicycle. Buckingham's gentle rural pastures and rolling hills made this pastime a very popular one at the turn of the 20th century. (Image from the collection of Norman and Yvonne Huppertz.)

In this portrait, a young boy is suited up for a day of hunting with his wooden toy bunny and his loyal hunting dog. Photographs like this accurately depict a family pastime that was shared in the plentiful woods of Buckingham and Lahaska. (Image from the collection of Norman and Yvonne Huppertz.)

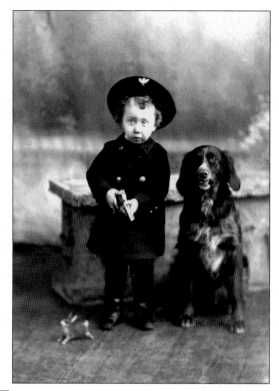

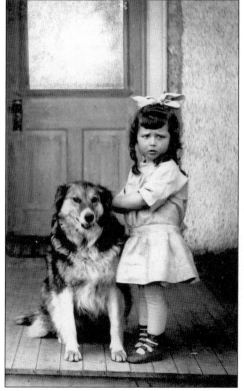

Pups were not only man's best friend, but a little girl's love as well. Victorian-era dogs were as cherished in their homes as the cherubic children they were photographed with. (Image from the collection of Norman and Yvonne Huppertz.)

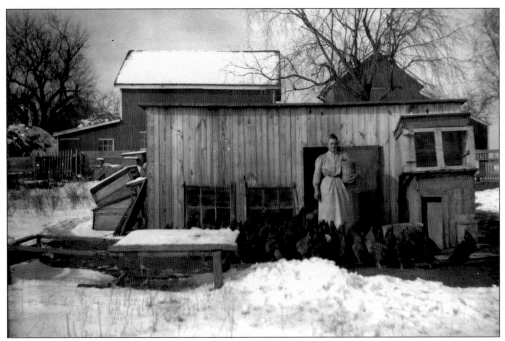

Our last stop in Lahaska originally had the name Hen Town. Covering approximately 42 acres, and originally populated by egg hatcheries, barns, and chicken coops, it was a prime location along the Old York Road corridor for a well-known entrepreneurial family to set up shop. The Jamison family, original owners of the Nathaniel Greene Inn, would eventually see their descendant Earl Hart Jamison take these 42 acres and turn them into the bustling tourist attraction named Peddlers Village. (Images courtesy of the New Hope Historical Society.)

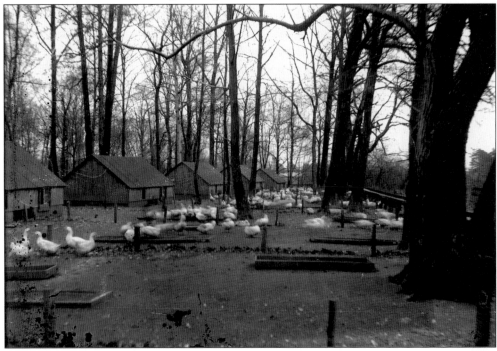

# *Three*

# NEW HOPE

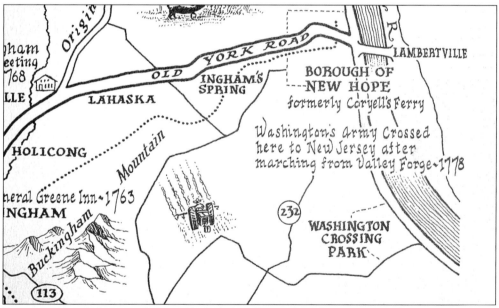

Here is a detailed view of the Old York Road corridor where it entered into New Hope, Pennsylvania. This developing town began its boom in the summer of 1717. A spirited carpenter named John Wells was the first to settle here, building his house along the riverside. Many followed his lead and built their homes along this waterfront of industry. Not only homes prospered, but businesses flourished here as well. With keen business sense, Wells recognized that in order for travelers to continue their trek along the York Road corridor, they needed to get across the Delaware River. In 1722 he established the first ferry to Lambertville, New Jersey. (Map courtesy of the Old York Road Historical Society.)

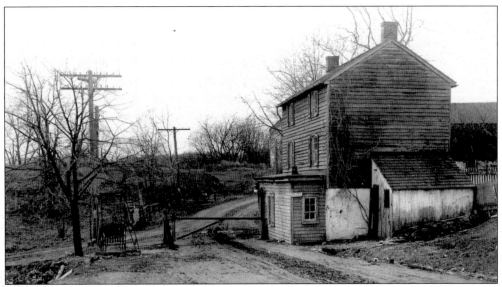

This is a c. 1870 view of the New Hope tollhouse. As seen in the photograph, the tollgate is down and waiting for the next weary traveler to approach. As tollgates were erected to collect tolls that helped to maintain the roads, there were those travelers known as "pikers" (a vernacular of the time) who didn't believe it necessary to do their financial part. A piker was a a traveler who took back roads to avoid paying tolls. (Image courtesy of the New Hope Historical Society.)

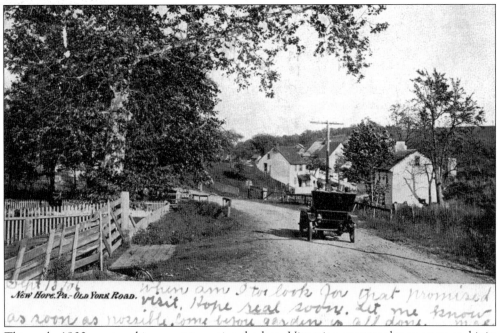

This early-1900s postcard is meant to entice the late–Victorian era traveler to come and join in on all the fun in New Hope, Pennsylvania. On the postcard dated September 18, 1906, the sender wrote: "When am I to look for that promised visit. Hope real soon. Let me know as soon as possible. Come before garden is all done." (Image courtesy of the Bucks County Historical Society.)

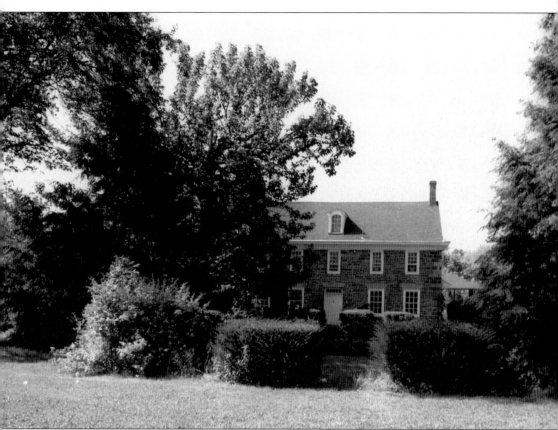

The above view shows the estate of one of New Hope's famous families, the Huffnagels. William K. Huffnagel was an engineer and diplomat; in fact, he was the first U.S. consul to India. Not only did he own a well-appointed home in New Hope, but he also kept a residence in Calcutta, India. Although he was busy overseas, Huffnagel did not neglect his hometown. He was the engineer for the extensive canal system that New Hope is known for. (Image courtesy of the New Hope Historical Society.)

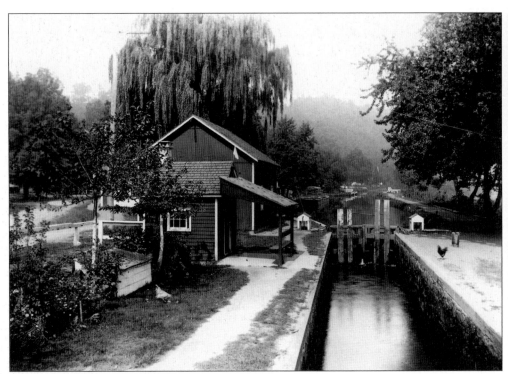

William Huffnagel was the engineering brains behind the canals Lehigh and Delaware division, a 60-mile stretch from Easton to Bristol completed in 1832. The canal system was part of the boom in a newly industrialized society, bringing jobs and economic growth to New Hope. (Images courtesy of the New Hope Historical Society.)

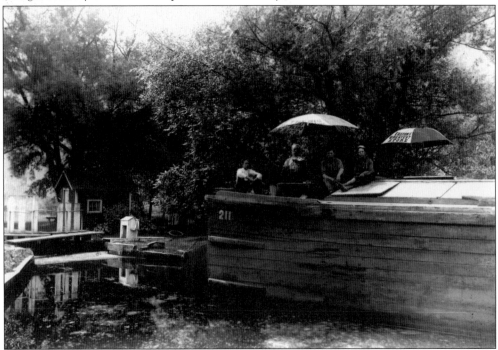

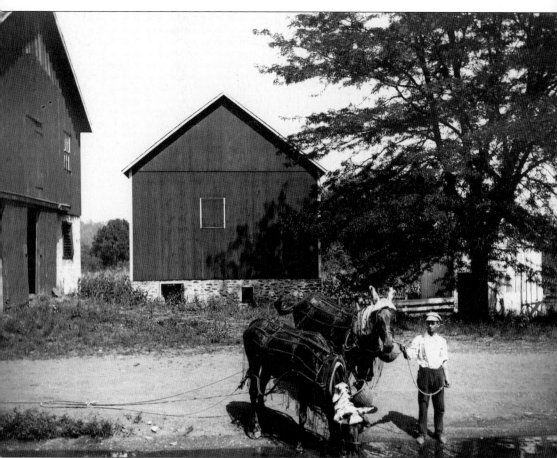

Built using New York's Erie Canal as its model, the canal in Pennsylvania connects Philadelphia, Pittsburgh, and Lake Erie over the course of 1,200 miles. The canal was used to bring coal from northwestern Pennsylvania to the southeastern Pennsylvania communities. By the late 1860s, about 100 boats were passing through New Hope each day. Boats were also used to carry a variety of freight—coal, lime, lumber, and hay—and livestock. (Image courtesy of the New Hope Historical Society.)

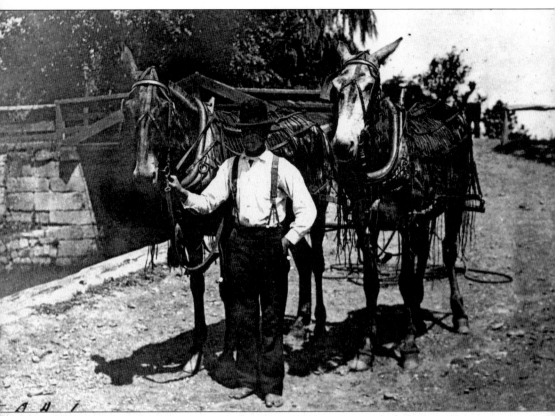

This *c.* 1899 image depicts a team of mules in full harness, ready for a day of labor. During the Civil War era, the canal system thrived, and 3,000 mule-drawn boats pulled more than a million tons of coal down the river in a year. (Image courtesy of the New Hope Historical Society.)

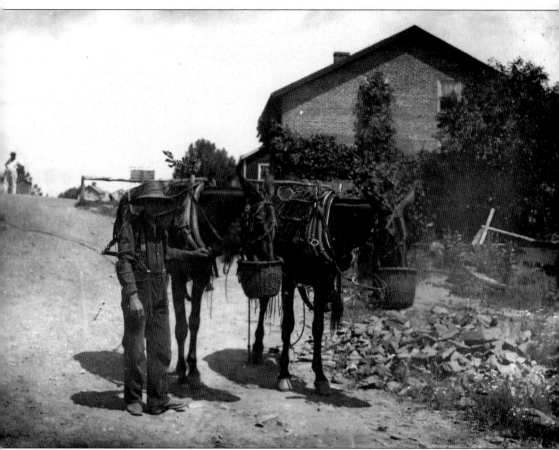

Life along the canal was difficult. Families who worked the canal started their average morning at 4:00 a.m., preparing the mule team by grooming and harnessing each mule. The mule team pulled an average of 80 tons of cargo over 30 miles, only stopping when lock tenders stopped operating and the boats could go no further. Rest came to the mule team and workers around 10:00 p.m. (Image courtesy of the New Hope Historical Society.)

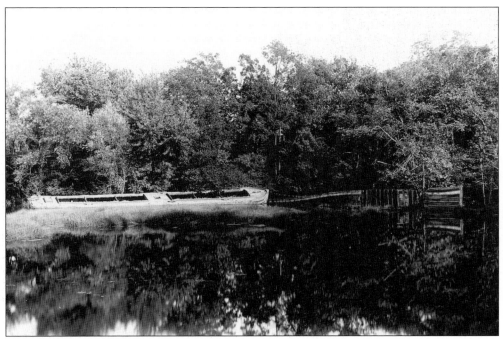

This c. 1899 canal view shows a portion of the waterway that has been dubbed the "graveyard for boats." Seen here is a canal boat that has been left on the banks in ill repair. During this era, it was not unusual for a traveler to abandon ship if the necessity arose. (Image courtesy of the New Hope Historical Society.)

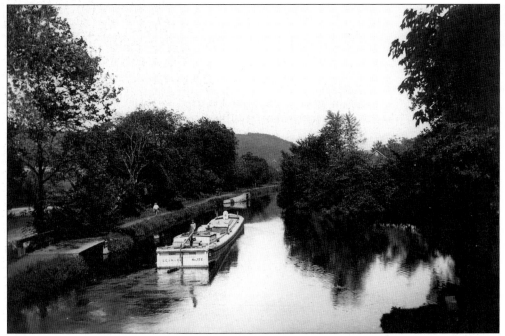

This is a fantastic image of a canal transport boat traveling south toward New Hope along the Delaware River Canal system. It seems a picturesque way of life, but the reality of life on the canal could be grueling. (Image courtesy of the New Hope Historical Society.)

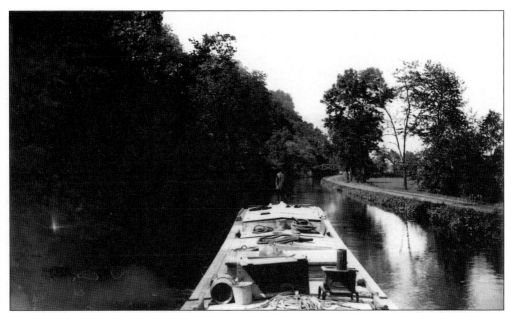

This image allows you to jump aboard the boat and see the Delaware River Canal as if you were navigating the river yourself. Offered is a rare glimpse of the deck of the boat. On board is a cast-iron stove that would allow deck hands to "fire up the grill" to cook and to provide heat for the canal boat workers when lock tenders closed up the gates and forced boats to stop traveling for the night. (Image courtesy of the New Hope Historical Society.)

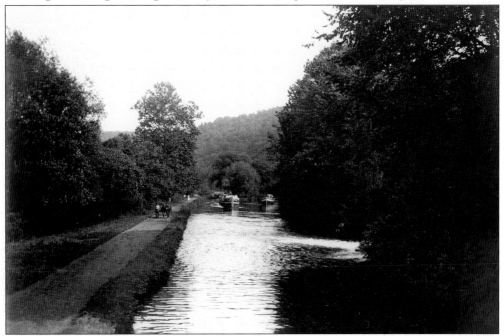

Pictured is a bustling 19th-century canalling community. On their way downriver toward the river town of New Hope, busy mules pull transport canal boats that may be filled with anthracite coal, or as it was called in the era because of its great value to the nation, "black diamonds." (Image courtesy of the New Hope Historical Society.)

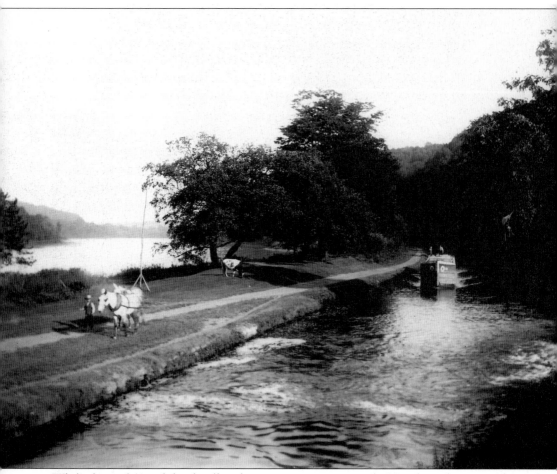

While the mules work hard pulling heavy cargo approximately 30 miles a day, a cow leisurely grazes in the pasture along the Delaware River Canal. The importance of agriculture and canal life to those who lived and prospered in the New Hope area cannot be forgotten. Weary laborers could stop and relax at a tavern or inn at the end of a long day on the canal. (Image courtesy of the New Hope Historical Society.)

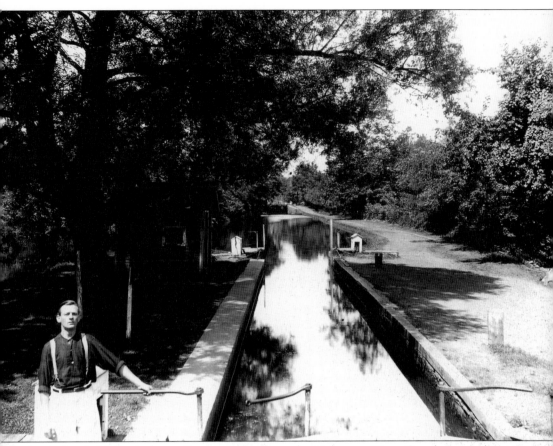

Lock tenders held the key to all movement along the Delaware River Canal. Located at various points along the canal were gates. Each day, lock tenders unlocked the gates at sunrise and locked down the gates around 10:00 p.m. When the gates were closed down, all movement along the canal came to a halt. This view shows a mighty lock tender, c. 1900, standing by his canal gate approximately one mile north of New Hope. (Image courtesy of the New Hope Historical Society.)

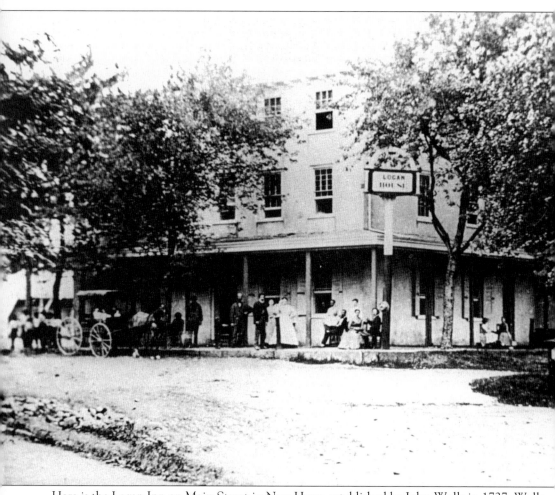

Here is the Logan Inn on Main Street in New Hope, established by John Wells in 1727. Wells is considered the first founding father of New Hope, and was responsible for establishing the first ferry in the area as well. The Logan Inn is one of the five oldest working inns in the United States today. It had its humble beginnings in 1722, when Wells purchased a license to run the ferry from Pennsylvania to New Jersey. With travelers passing through to cross the river on to New York, he also saw the need for a tavern and inn to provide a resting point along the Old York Road corridor. (Image courtesy of the New Hope Historical Society.)

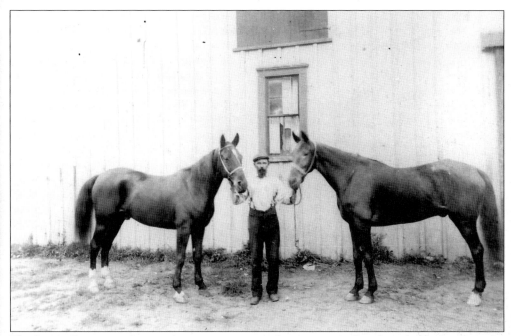

The Logan Inn not only served as a resting point for weary travelers, but also had a livery for weary horses to rest their hooves. Depicted here are a stable hand and two horses, well rested and ready for the road. (Image courtesy of the New Hope Historical Society.)

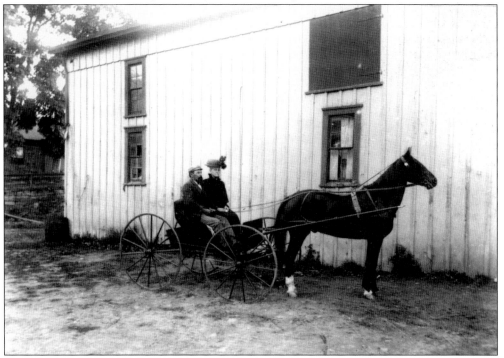

This handsome New Hope couple, with their single-drawn carriage, appear ready to take a stroll down Main Street. One of the livery's main goals was to keep guests actively exploring the area. (Image courtesy of the New Hope Historical Society.)

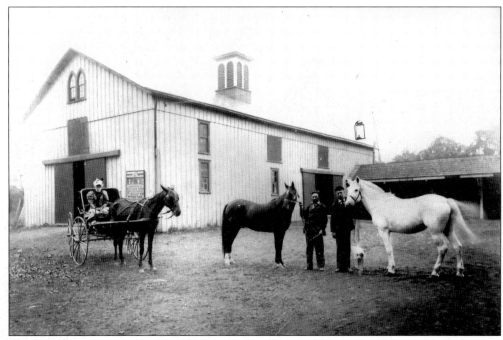

The Logan Inn livery served as what in modern day would be referred to as a valet service, rental service, and car park. This picture shows a single-horse buggy and several individual horses that were available to ensure Logan Inn guests could travel in style to surrounding inns and taverns, across the bridge to Lambertville, New Jersey, or north on Main Street to the artists' colony at the Phillip Mills. (Image courtesy of the New Hope Historical Society.)

This portrait is a wonderful image of stable hands outside the livery. The life of a New Hope stable hand was a busy one. With tourists and cargo carriers using New Hope as a stopping point, there were always horses in need of rest, water, and grooming, along with stables and equipment that needed cleaning and attention as well. (Image courtesy of the New Hope Historical Society.)

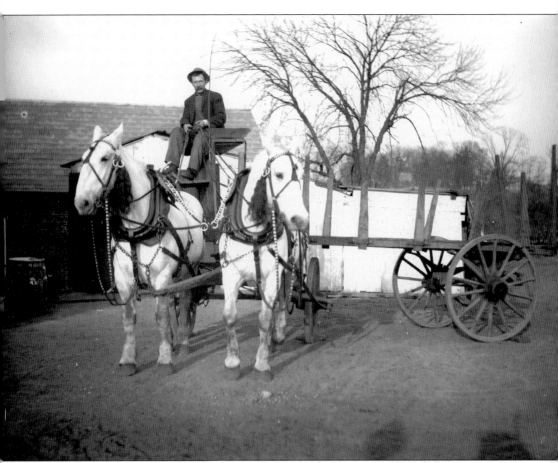

Pictured in this 19th-century view are two draft horses pulling a wagon. The mills relied on the horse-drawn wagons to transport goods such as silk and paper to the ferries, barges, or trains. Once aboard, New Hope's goods would then make the journey to the cities of Philadelphia and New York. (Image courtesy of the New Hope Historical Society.)

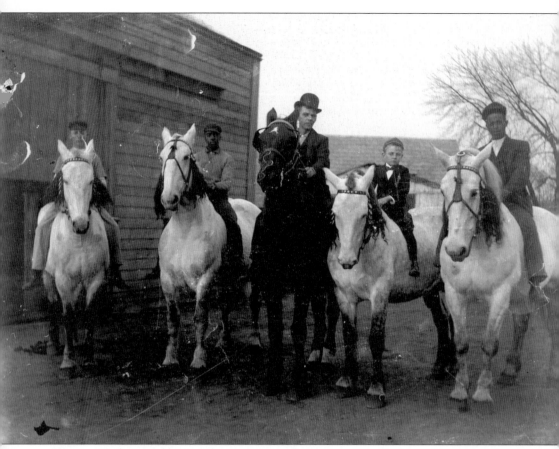

Sitting atop their workhorses, these young gentlemen pose grandly for an occupational portrait. Shown are three unidentified stable hands along with a man and his son; the youngest stable hand is in training. Once again, this photograph demonstrates the racial diversity of New Hope. (Image courtesy of the New Hope Historical Society.)

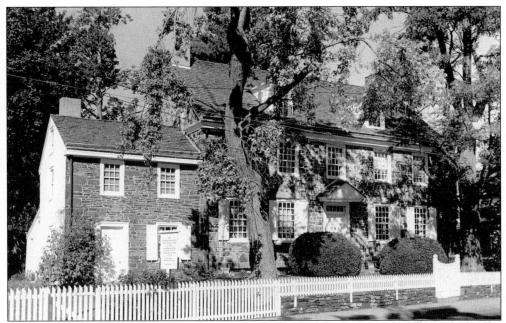

Benjamin Parry was one of New Hope's wealthiest and most prestigious citizens. Establishing his roots even further in the community, he married into the historic Paxson family. Parry is credited with giving the town its name, and he was the town's first burgess when the borough was incorporated in 1837. He owned the mansion pictured (above and below), as well as the mills in the town that provided most of the locals with employment. Tragically, the lumber and flour mills burned to the ground in 1790. These fires threatened the economic security of the town and left many workers worried about their own survival. When Parry rebuilt the mills, he aptly named them the New Hope Mills. Citizens of the town followed suit and named the little village by the river New Hope as well. (Images courtesy of the New Hope Historical Society.)

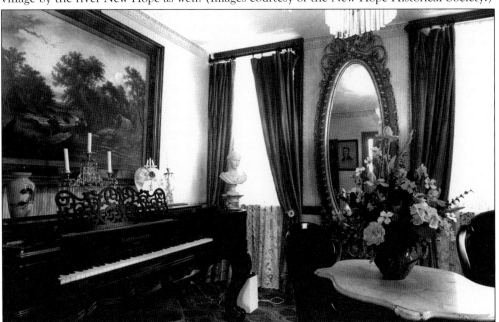

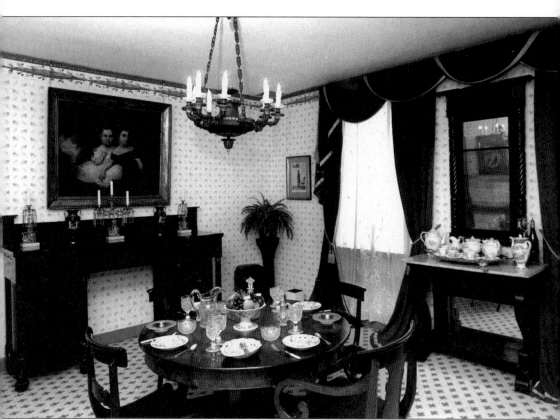

This interior view of the Parry Mansion's dining room shows the wealth and prosperity of one of New Hope's founding fathers. Great thought went into every detail of the room, from the elegant mahogany sideboard to the delicate patterned transferware tea set. (Image courtesy of the New Hope Historical Society.)

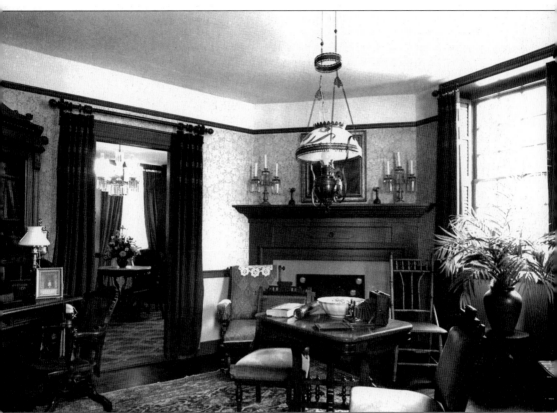

This view inside the Parry Mansion affords us a glimpse of its masculine side, in this room where the entrepreneurial-minded Benjamin Parry contemplated his next business ventures. (Image courtesy of the New Hope Historical Society.)

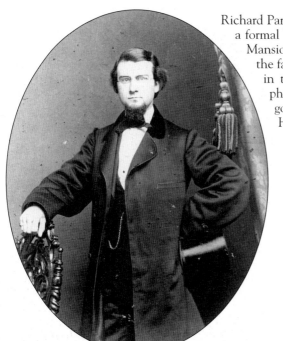

Richard Parry, grandson of Benjamin Parry, poses for a formal Victorian portrait. He lived in the Parry Mansion and continued to build the prestige of the family name. The Parry wealth is apparent in this view. Only the very rich would be photographed with a fur-lined top hat and gold watch fob. (Image courtesy of the New Hope Historical Society.)

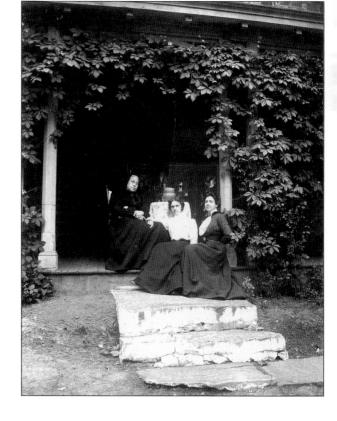

In this rare and informal Victorian-era portrait, from *c.* 1900, the Parry aunts are lounging on the back porch; this is a glimpse into the relaxed life along the river. (Image courtesy of the New Hope Historical Society.)

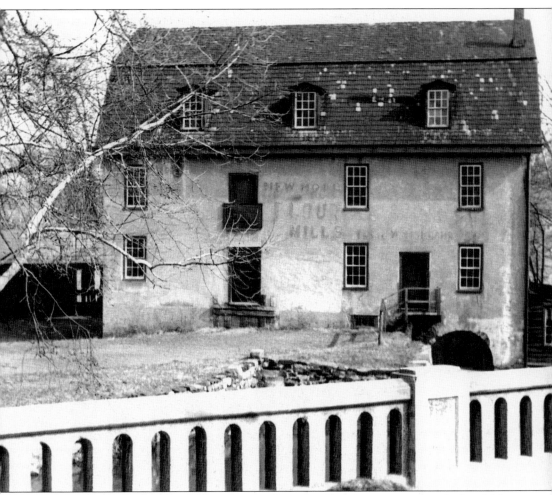

The New Hope Flour Mill was one of businessman Benjamin Parry's acquisitions in the late 18th century. It was purchased from Dr. Joseph Todd in 1784. Parry also established a flaxseed oil mill and extensive lumber mills. (Image courtesy of the New Hope Historical Society.)

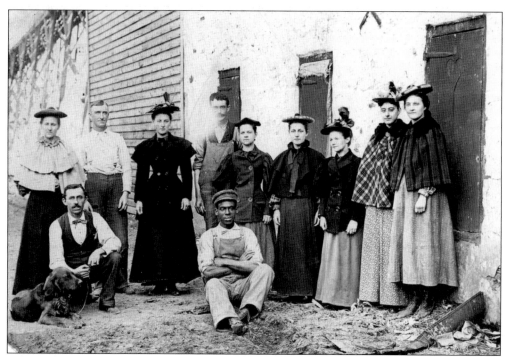

Over the course of several generations, the milling industry took hold and became well established in the town of New Hope. Pictured above and below are some of the local mill workers. Still growing even throughout the 19th century, the mills provided employment and economic stability to the town. Not only did the mills produce flour, flax seed, silk, and lumber, but they also produced a growing community. This development created a need for general stores, taverns, schools, and churches. (Images courtesy of the New Hope Historical Society.)

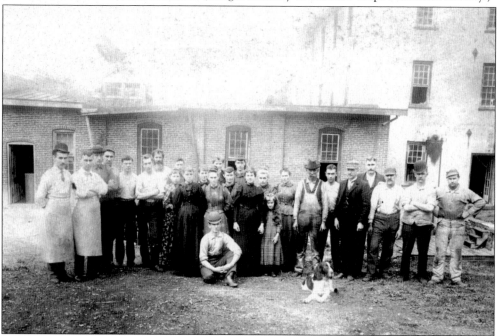

This little girl didn't miss out on the fun of carriage driving and travel. This is a typical image, as most children learned at an early age the carriage skills needed in later life.(Image from the collection of Norman and Yvonne Huppertz.)

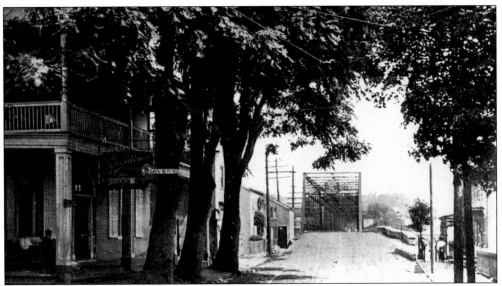

Shown is the intersection of Main Street and Bridge Street of New Hope, Pennsylvania. In the distance is the famed bridge that replaced the ferry system in New Hope. The bridge provided quick and easy passage for weary travelers on their way to New York. Crossing the Delaware River into New Jersey could be done with ease. (Image courtesy of the New Hope Historical Society.)

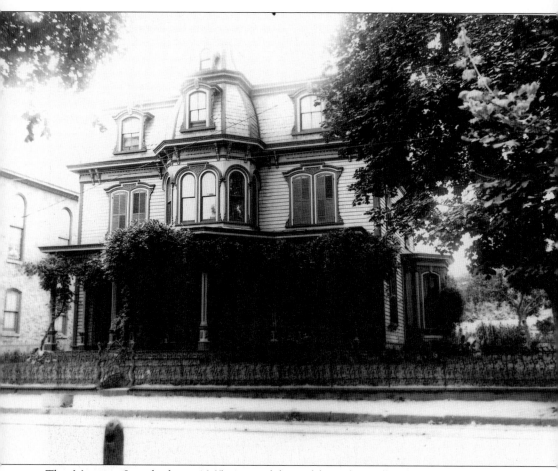

The Mansion Inn, built in 1865, was a labor of love for well-respected local agricultural businessman Charles Crook. He built the mansion for his wife in the style of the Second French Empire. It boasted the distinction of being the first home to have running water in all of Bucks County. In the mid-1930s the house was sold to New Hope's renowned doctor Kenneth Leiby; it is where Leiby lived with his family and practiced medicine. (Image courtesy of the New Hope Historical Society.)

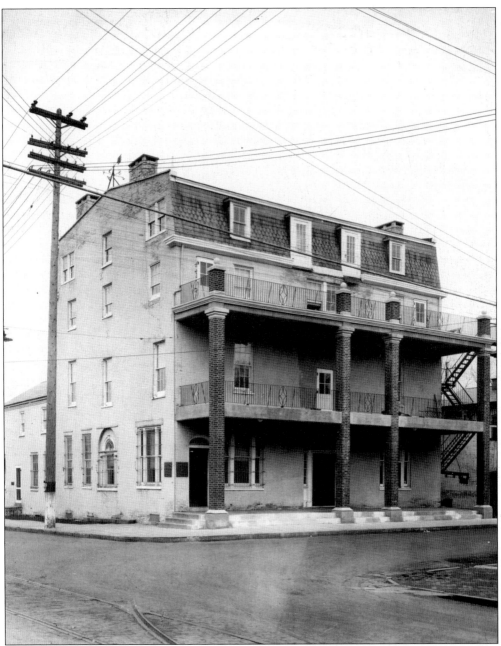

The Solebury National Bank on the corner of Bridge and Main Streets, seen here *c.* 1800, held the deed to the bridge that connected New Hope, Pennsylvania, to Lambertville, New Jersey. In a scandal that was far reaching, the bank failed in 1826 and the bridge was sold off to pay the bank's debts. Those who held bank notes lost their money. The building has since had many functions, among them serving as a library space and coffee shop. (Image courtesy of the New Hope Historical Society.)

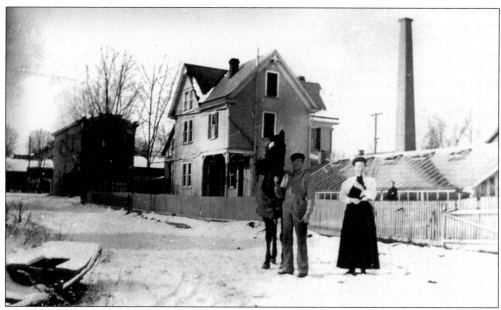

The Faust family was a distinguished family in the area, and was noted as being accomplished in agriculture. With the advent of the automobile, the quick-thinking Fausts partnered with the Austins and opened The General Tire, a garage dedicated to repairing the new modern-age marvel, the Model T. (Images courtesy of the New Hope Historical Society.)

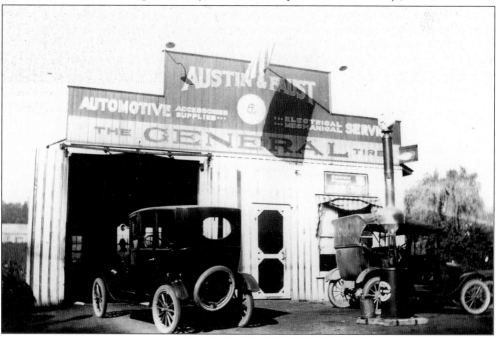

This 19th-century family stands outside their New Hope–area home, which is encircled by a white picket fence. Judging from these happy faces, life was good in this river town. (Image courtesy of the New Hope Historical Society.)

Life in New Hope was not without patriotism. This *c.* 1900 family sits outside their home along the river. The two gents in the foreground are holding a 45-star American flag. The 45th star was added in 1896 in recognition of the addition of Utah as a state of the Union. The number of stars would remain at 45 until 1907. (Image courtesy of the New Hope Historical Society.)

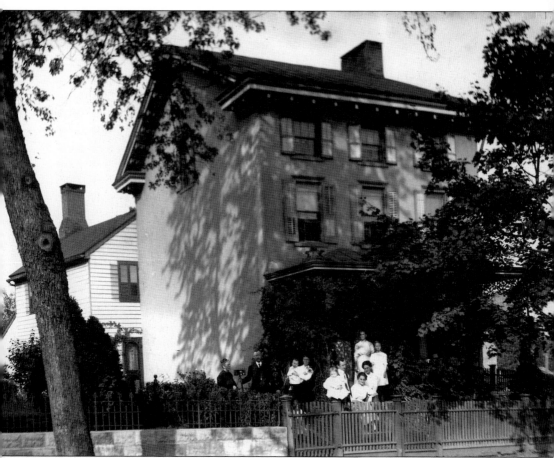

This entire family has gathered on their front porch with camera in tow, ready to capture their budding and prosperous neighborhood on film. From this view it can be noted that land development is occurring rapidly, and families are choosing to raise their families along the Delaware River. (Image courtesy of the New Hope Historical Society.)

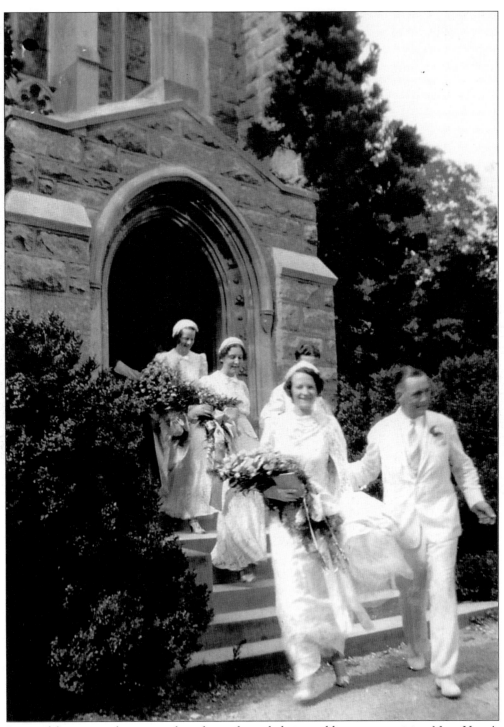

Pictured here are a happy newlywed couple and their wedding party exiting New Hope's well-known Old Stone Church. It has been a landmark on Main Street since the 1880s, when it served as one of only three churches in the area. (Image courtesy of the New Hope Historical Society.)

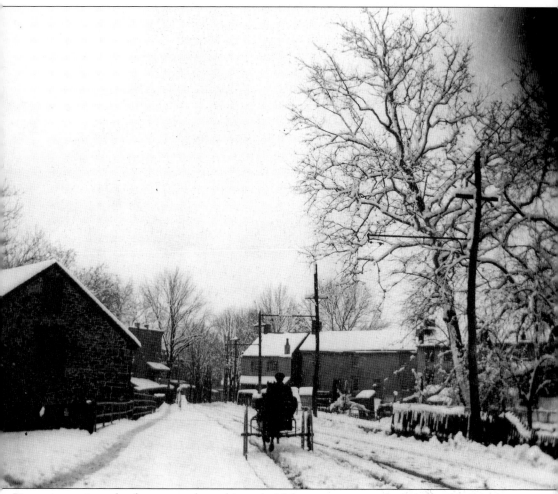

Picturesque winter landscapes, such as this early-19th-century view of a horse and buggy on Main Street, have been a source of inspiration to local and international artists alike. Just a few more steps in the snow will land this buggy in front of the Parry Mansion. (Image courtesy of the New Hope Historical Society.)

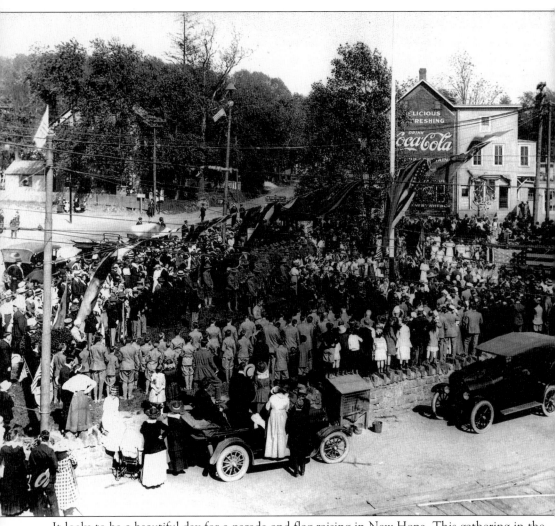

It looks to be a beautiful day for a parade and flag raising in New Hope. This gathering in the center square of New Hope offers a look back at post–World War I patriotism. With doughboy soldiers in attendance and a wealth of American flags, it appears that the town of New Hope was out in full force to pay respect and celebrate a victory. (Image courtesy of the New Hope Historical Society.)

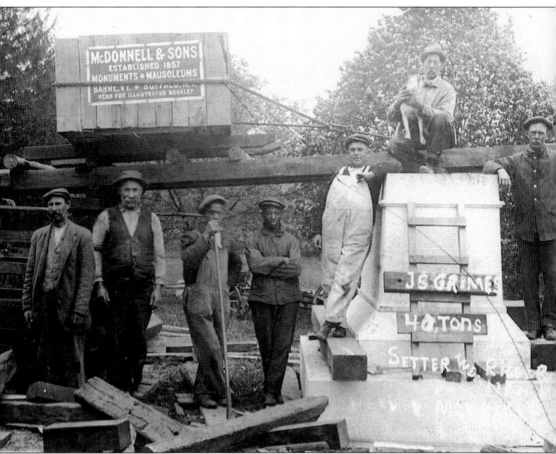

As New Hope continued to expand in business and community, there was an increased need for service industries. McDonnell & Sons, established in 1857, specialized in monuments and mausoleums. (Image courtesy of the New Hope Historical Society.)

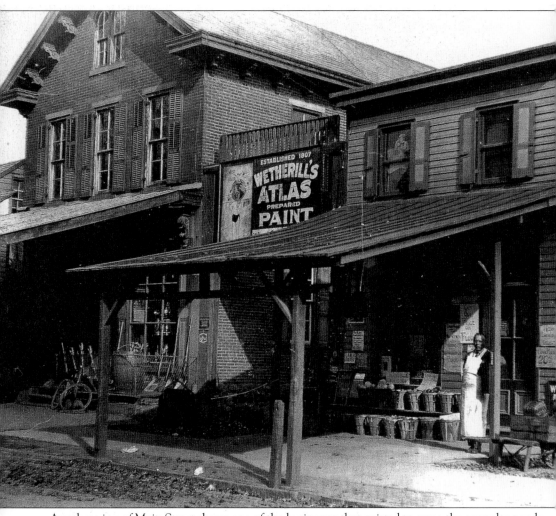

Another view of Main Street shows one of the businesses that existed to serve the everyday needs of residents and visitors to New Hope. Notice the storekeeper leaning against a post, waiting for customers to stop in and purchase his fruits and vegetables. Also note the early advertising billboard for Wetherill's Atlas Prepared Paint. With the influx of residents and construction of new housing, supported by the local lumber mills, the sign is indicative of the town's growth. (Image courtesy of the New Hope Historical Society.)

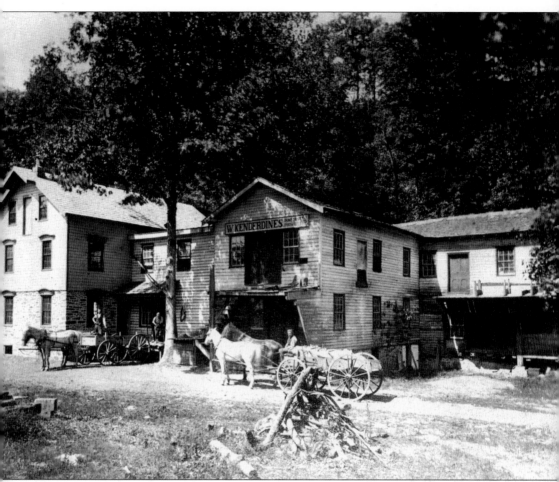

Three miles up the road from New Hope is the home of yet another famous local family, the Kenderdines. This Quaker family escaped religious persecution in North Wales. After several generations, John Kenderdine and his family settled in the New Hope area. During this time the family shared in the milling, lumbering, and farming boom throughout the late 1700s and 1800s. The Kenderdine family is reputed to have played a large role in the early construction of New Hope. John Kenderdine had three sons. Thaddeus S. and Robert both served in the Civil War. Robert Kenderdine was killed in the historic Battle of Gettysburg. Watson, the third son, did not join the fight but stayed home and helped maintain the family business. (Image courtesy of the New Hope Historical Society.)

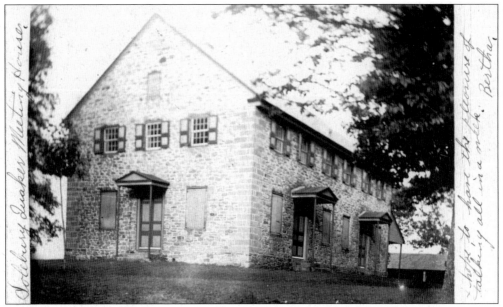

This is an early-1800s photo postcard of the Solebury Friends Meeting House, built in the New Hope borough. The message on the card reads, "I hope to have the pleasure of talking [to you] all in a week, Bertha." (Image courtesy of the New Hope Historical Society.)

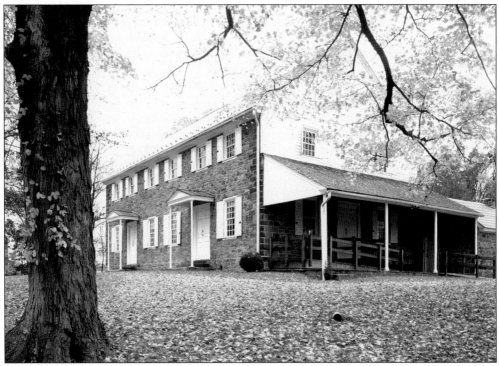

The Solebury Friends Meeting House was founded in 1806 by members of the Buckingham Friends Meeting House who wanted a place to worship closer to home. The resourceful Solebury Friends used the same "double" layout found in the Buckingham meetinghouse, and used local lumber and stone to construct this building. (Image courtesy of the Ron Saari.)

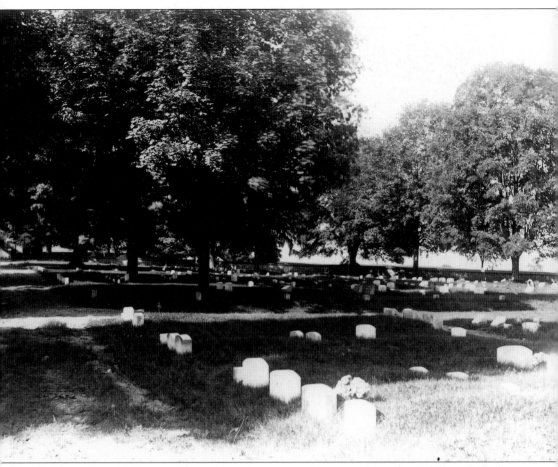

The Solebury Friends Burying Ground sits just across the street from the Solebury Friends Meeting House in New Hope. The cemetery was established four years after the meetinghouse in 1810. Much like the Buckingham Friends Meeting House graveyard, the Solebury Friends Burying Ground offers a peaceful and picturesque resting place for the Solebury Quakers. Many of New Hope's notable families have been buried here, including, once again, the Fells, Kenderdines, and Paxsons, as well as Civil War soldiers. (Image courtesy of the New Hope Historical Society.)

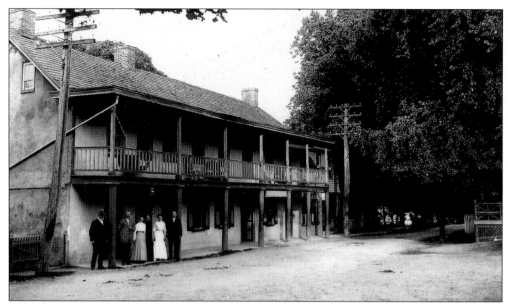

This is an exterior view of the Black Bass Inn, built *c.* 1740 just a few miles north of New Hope. This inn beside the Delaware River hosted many travelers who needed respite from the hardships of Colonial travel. However, the inn never played host to George Washington or any of the members of the Continental Army. The owners of the inn were loyal to the British Crown during the Revolutionary War era. (Image courtesy of the New Hope Historical Society.)

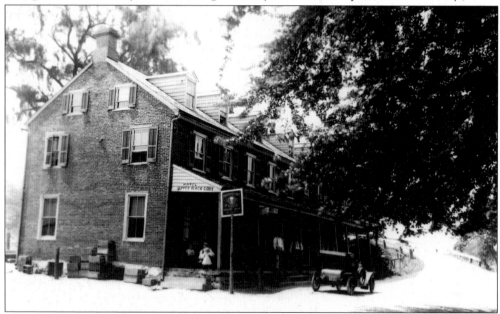

This inn stood just around the corner from the Black Bass Inn, also north of the New Hope borough. Taverns and inns like this one were plentiful along the Delaware River. They were helpful to weary travelers making their way from Philadelphia to New York. Not only did the inns serve as resting points for stagecoach horses and drivers, but they also provided refuge from hostile Native American tribes in the woods. Stopping to spend the night in a secure inn was a wise practice for early trekkers. (Image courtesy of the New Hope Historical Society.)

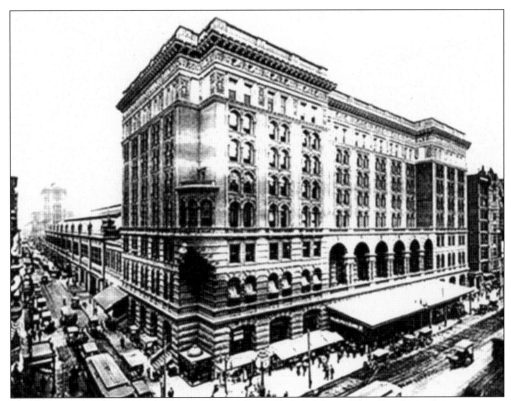

Pictured is the original Reading Terminal in Philadelphia. The Reading Company was established in 1833. Its main initiative was originally the transport of anthracite coal from the western regions of the state out to the east. The Reading Company helped to move the country into the industrial revolution by serving the most populated regions. By 1870 the Reading Company was the largest corporation in America.

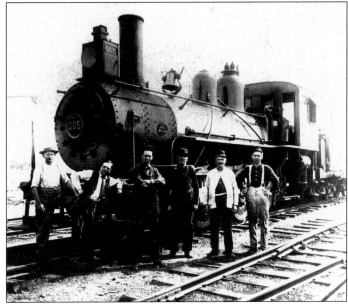

With the industrial revolution in full swing, the railroads began to supersede the mule-pulled barges that were initially used to transport coal and other goods for local industry. (Image courtesy of the New Hope Historical Society.)

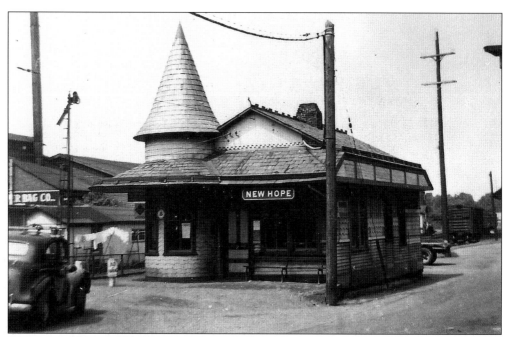

Soon it would be possible for travelers to ride the rails as a means of transportation. Pictured is the New Hope train station with its Victorian-style architecture. No longer needing the service of horse and buggy, modern man's iron horse could now transport a family in style, direct from Philadelphia's Reading Terminal to the New Hope Station. (Images courtesy of the New Hope Historical Society.)

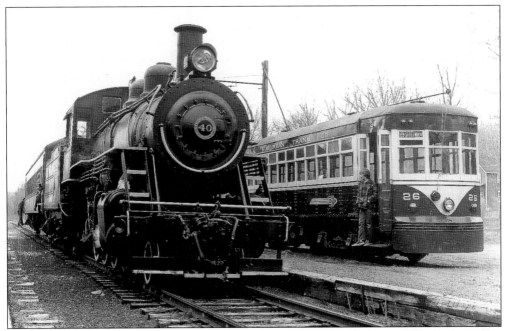

As the industrial age pushed forward, train technology brought about an offshoot, the trolley system. This new technology was used not only to transport coal and other goods, but also afforded tourists and locals alike a more extensive means of transportation within suburban communities. (Image courtesy of the New Hope Historical Society.)

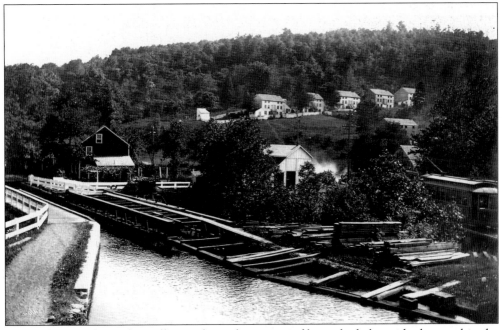

This early view shows the trolley tracks in the process of being laid alongside the canal in the late 19th or early 20th century. This new mode of transportation would ease the load of the canals and provide faster delivery of coal from western Pennsylvania to the southeastern part of the state. (Image courtesy of the New Hope Historical Society.)

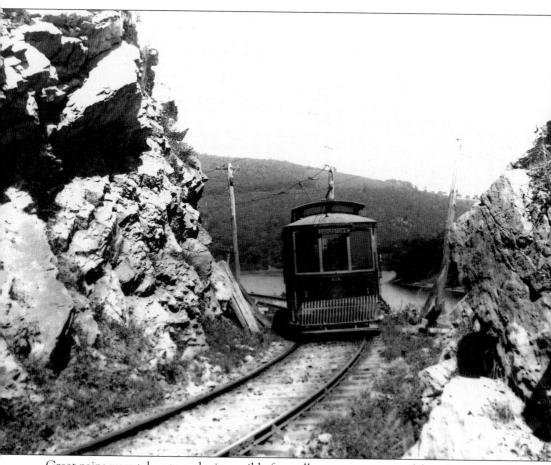

Great pains were taken to make it possible for trolleys to transport coal from Easton southward to towns like Doylestown and, finally, New Hope. Laborers used dynamite to cut their way through mountainsides to lay tracks for the trolley transport cars. (Image courtesy of the New Hope Historical Society.)

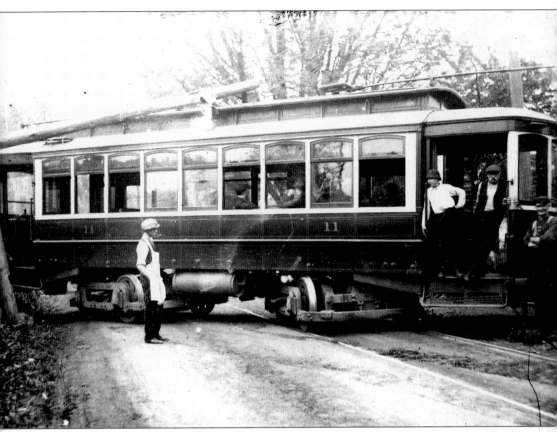

Pictured is one of New Hope's earliest trolleys. While it may have saved commuters time to travel through New Hope, it was not without its troubles. Seen here is an early-1900s trolley crash; the back wheels became derailed, and the trolley jack-knifed off of its tracks. Upon closer examination, it is clear that passengers are still inside the trolley, waiting for their journey to resume. These incidents were taken with a spirit of adventure in this new age of travel. (Image courtesy of the New Hope Historical Society.)

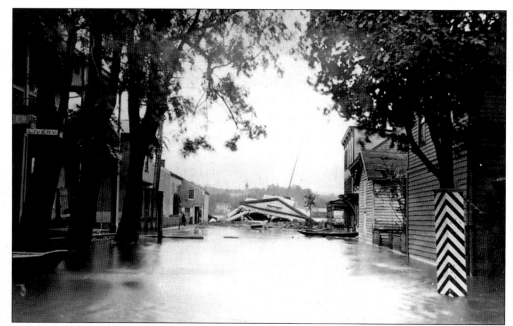

The notorious flood of 1903 left the town of New Hope in despair. Over 14 inches of rain fell in the first four days, causing the Delaware River to rise 28 feet above its banks. This flood destroyed the original covered bridge that connected New Hope to Lambertville, New Jersey. At least three men lost their lives. (Image courtesy of the New Hope Historical Society.)

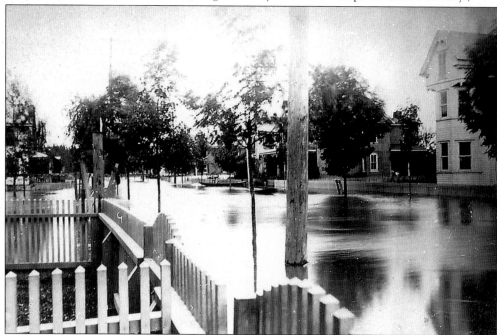

The flood left New Hope in total isolation. The waters completely washed out Main Street, closing shops, liveries, inns, and taverns. Also, the waters shorted out the trolley and railway systems, leaving no service between Philadelphia and New York City. (Image courtesy of the New Hope Historical Society.).

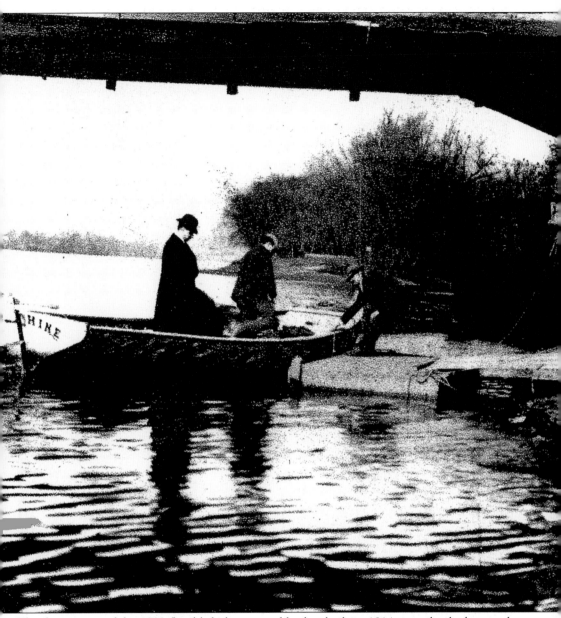

The devastation of the 1903 flood left the covered bridge, built in 1814, completely destroyed and impassable. To get travelers back and forth between New Hope and Lambertville, the ferry system was reinstated. Pictured here is the widely used Sunshine Ferry. (Image courtesy of the New Hope Historical Society.)

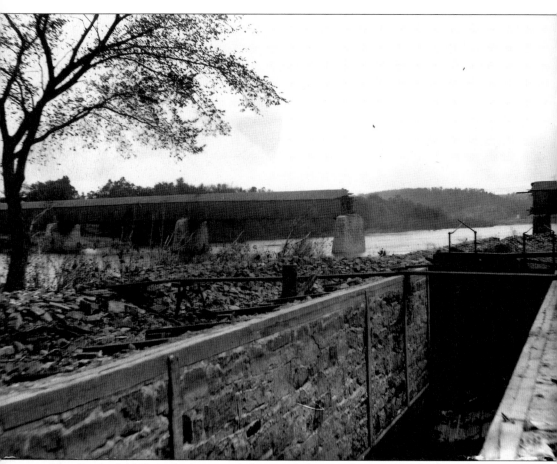

The flood of 1903 washed out and destroyed the wooden covered bridges that connected Pennsylvania to New Jersey. Bridges had become the main means of passage between the neighboring towns of New Hope, Pennsylvania, and Lambertville, New Jersey. When the bridges were impassable, the ferries were put back in use. After the catastrophic flood, the wooden covered bridge in New Hope that had been built through the efforts and financial backing of Benjamin Parry was completely destroyed. The John A. Roebling Company was brought in and commissioned to build an all-steel bridge structure that could withstand Mother Nature's forces. (Image courtesy of the New Hope Historical Society.)

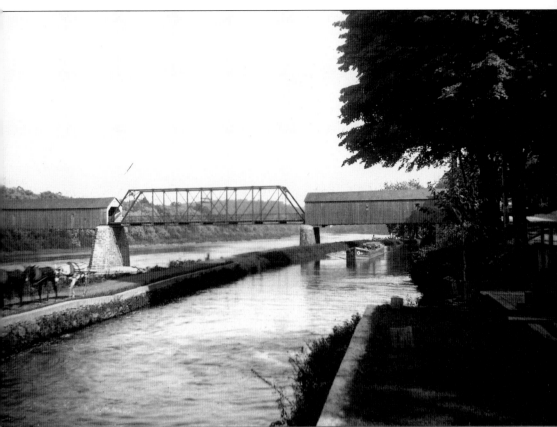

After the waters finally receded, crews were sent out to repair the bridges. Ten days later, two trains collided just outside of New Hope, one of which was carrying workers who were on their way to repair the bridges. One of the most horrific accidents of its time, 17 laborers were killed and another 33 were injured; many were permanently crippled. These casualties were suffered by laborers who had been packed shoulder to shoulder inside a train car. The workers were mostly African American, Italian, and Hungarian immigrants from Trenton. (Image courtesy of the New Hope Historical Society.)

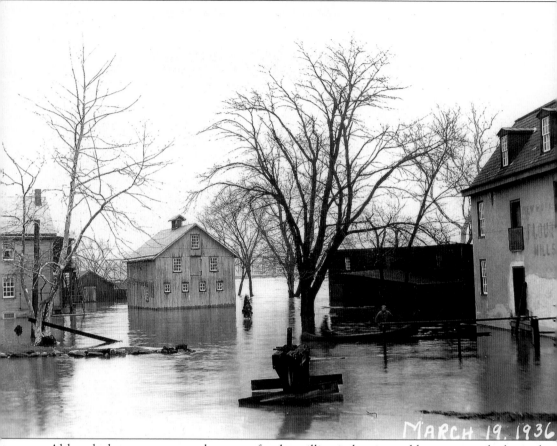

MARCH 19, 1936

Although there were many advantages for the milling industries and businesses to be located on the waterways, floods continued to be devastating natural occurrences. This is a scene of the Parry Flour Mill and other local buildings in March 1936, when another flood struck the town. Residents used small boats and canoes to check on neighbors and run supplies until the waters receded. (Image courtesy of the New Hope Historical Society.)

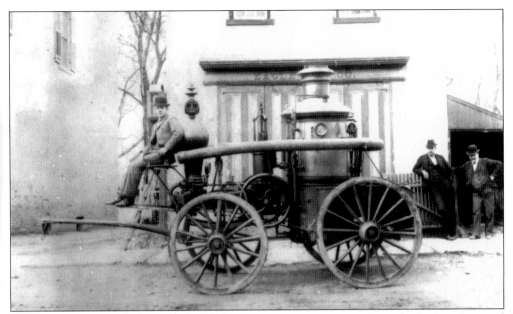

A town meeting was called in New Hope in the summer of 1828. Citizens of both New Hope and Lambertville gathered to discuss the procurement of a fire engine and the establishment of a formal fire company. It was decided that the engine would be housed near the Delaware covered bridge, so that if the engine was called into service, it could respond quickly on either side of the river. Thus the Eagle Fire Company was born. (Image courtesy of the New Hope Historical Society.)

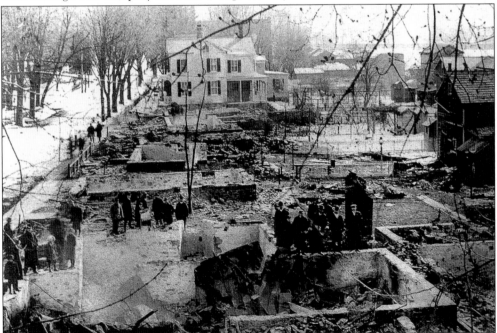

Tragedy struck on February 5, 1912, when a fire began and spread throughout the town of New Hope. In this view are several homes and other buildings that were burned down to their foundations. Families and members of the fire company stand among the ruins. (Image courtesy of the New Hope Historical Society.)

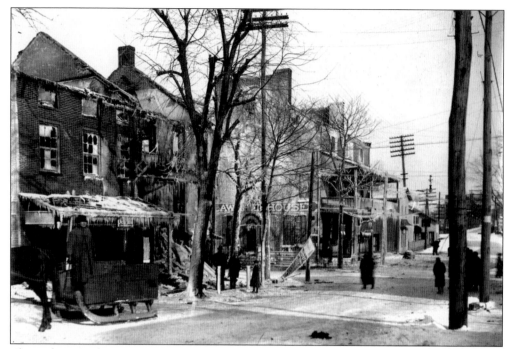

These photographs taken after the 1912 New Hope fire provide two views of the devastation caused by the blaze. The house seen in both images was the "Delaware House," the home of George Meldrum. Ironically, it was at Meldrum's home, 90 years prior to the fire, where meetings were held to discuss the establishment of a fire company for the town. (Images courtesy of the New Hope Historical Society.)

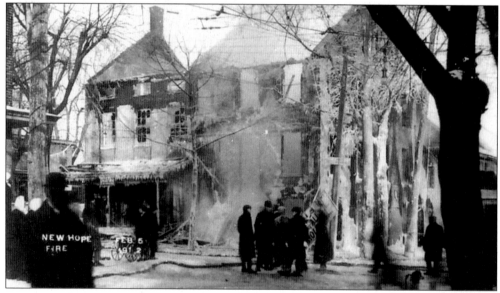

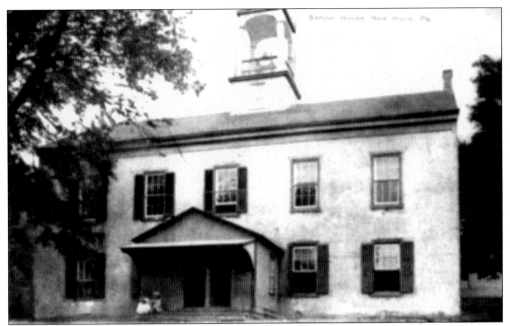

The New Hope School, established *c.* 1820, was located just off of the Old York Road corridor. Frenchman Philip Fouchette and his wife operated the school. Throughout the 1800s, the school remained active under the leadership of Kitty Burroughs. It also served as a Presbyterian Sunday school. (Image courtesy of the New Hope Historical Society.)

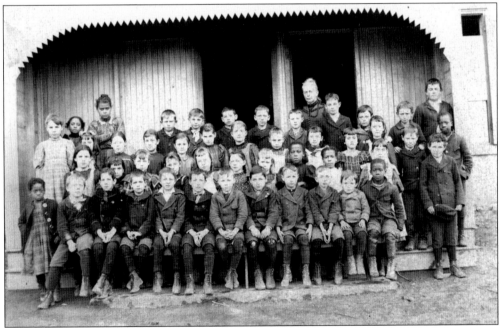

One teacher is present in this class photograph taken in the 1880s at the New Hope Elementary School. There was diversity in these early Bucks County classrooms, as is apparent among this group of children, with African American boys and girls sharing classes with Caucasian boys and girls. (Image courtesy of the New Hope Historical Society.)

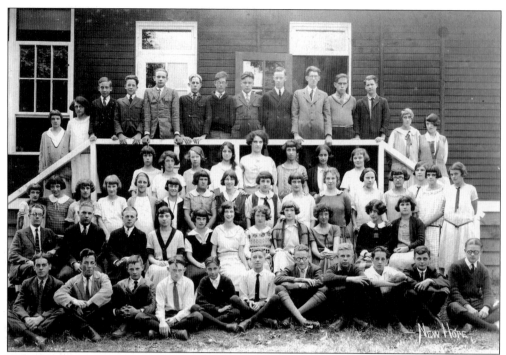

Assembled outside the schoolhouse is the New Hope student class of 1937. True to the style of the era, the girls all sport similar bob haircuts, and the boys are a finely pressed bunch in their suits and ties. (Image courtesy of the New Hope Historical Society.)

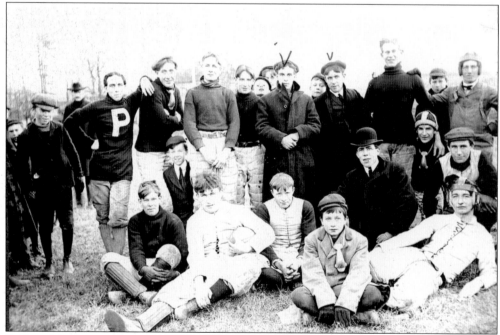

Gathered for a team photograph are members of a late-19th-century New Hope School football team. Smiling and still in their uniforms, the players appear to have just won their latest game. (Image courtesy of the New Hope Historical Society.)

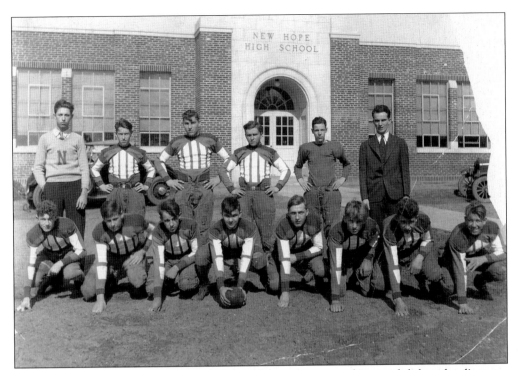

In future years, as the New Hope High School became more modern, so did the school's sports uniforms. Well posed in their traditional team portrait, these tough teammates made for a fine yearbook photograph that year. (Image courtesy of the New Hope Historical Society.)

Pictured is New Hope High School's 1948 basketball team. This squad looks poised and ready for victory. Although the region was not recognized for its athletics, New Hope High School teams were ready to prove to naysayers that they were a force to be reckoned with. (Image courtesy of the New Hope Historical Society.)

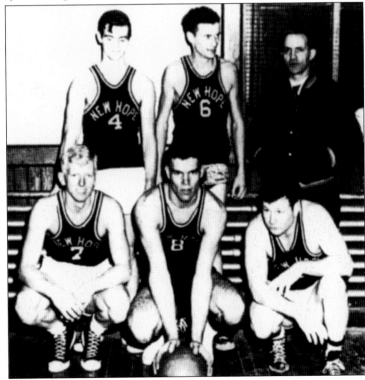

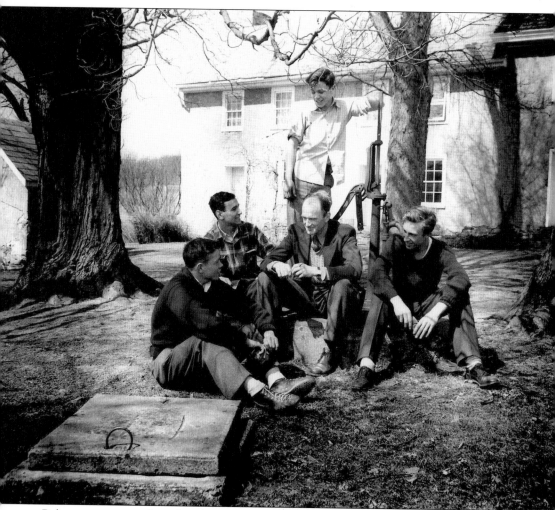

Below we see an informal and intimate class session of teacher among students outside the Solebury School of New Hope. The school is a private college-preparatory school. This teacher recognized the importance of environment in learning. (Image courtesy of the New Hope Historical Society.)

In this Victorian-era image we see a bright-eyed and smiling toddler clutching her stuffed bunny rabbit. She stands atop a highly stylized scrollwork wicker chair, popular during this time. She is obviously the beloved child of an affluent New Hope couple. (Image from the collection of Norman and Yvonne Huppertz.)

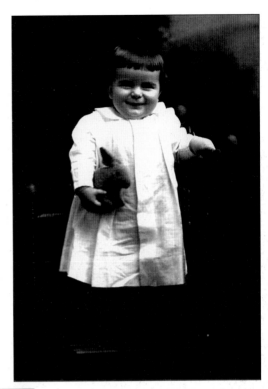

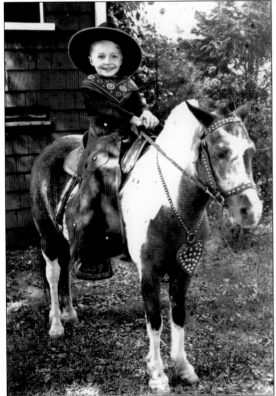

Ready for the New Hope gold rush, this young lad sits atop his paint pony in full cowboy garb. With the popularity of Gene Autry, Roy Rogers, and Dale Evans reaching all-time heights in the 1940s, this local boy was a typical youngster in a nation in love with the Wild West. (Image from the collection of Norman and Yvonne Huppertz.)

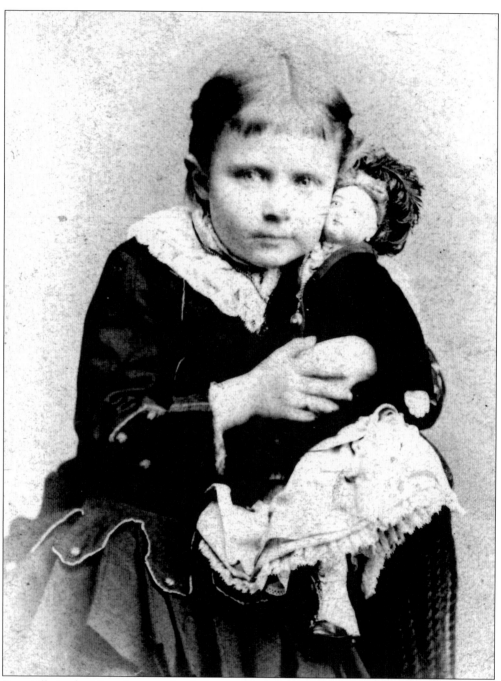

Especially in the Victorian era, the doll was a mirroring image of the times and trends. During the 19th century, dolls were imported almost solely from France, Germany, and Switzerland. Their faces and hands were typically made of fine porcelain, and the most popular dolls were miniature royalties—princes and princesses in glamorous dress. This young resident of New Hope clutches her prized porcelain treasure while posing for the camera. This image provides further evidence of the affluence of the local population. (Image from the collection of Norman and Yvonne Huppertz.)

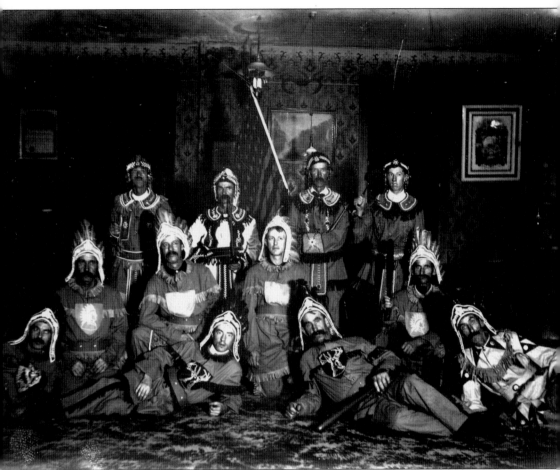

This 19th-century portrait of a New Hope gentlemen's club (possibly the Elks), patriotically posed with the American flag behind them, shows that pageantry didn't stop with the ladies of the town. (Image courtesy of the New Hope Historical Society.)

Just two miles north of New Hope is the Phillips Mill. Built in 1756 by Aaron Phillips, it served as a water-powered gristmill and was also occasionally used as a community center by locals. Any history of New Hope would be lacking without the inclusion of the Phillips Mill. In the early 1900s, it was here that New Hope was born as a refuge to the arts community. (Image courtesy of the New Hope Historical Society.)

Artist William Lathrop fell in love with the river village of New Hope and its surrounding region. He purchased the Phillips Mill in 1899 and turned it into his home and studio. It was here that he began to attract other prominent artists of the time, including the highly regarded Edward Redfield, to the area. Each week Lathrop and his wife, Anne, hosted tea parties for colleagues, and these gatherings gave rise to the New Hope artists' colony. (Image courtesy of the New Hope Historical Society.)

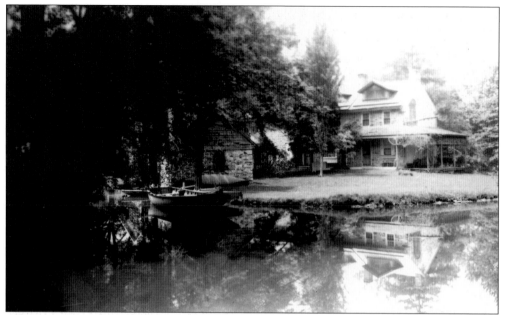

Afternoon teas and social gatherings were held here in William and Anne Lathrop's backyard oasis. It is said that artists Henry and Florence Snell were the first to visit the Lathrops here in 1898. From that day forward, the Lathrop home would be a mecca and educational home to the local arts community. (Image courtesy of the New Hope Historical Society.)

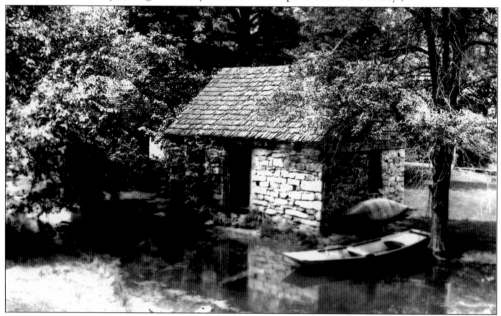

Taken *c.* 1900, this image of the Spring House at the Phillips Mill was shot in the early days of the mill, as it was becoming an artists' colony. The Lathrop home served as a gorgeous muse for all who visited. The artists of the mill were influenced by the French Impressionists, and they believed that no other place in the region resembled the European landscapes that inspired the greats of the art world more than New Hope did. (Image courtesy of the New Hope Historical Society.)

This portrait of Edward Redfield, by Wayman Adams, captures the artist's astute gaze at his subject. Redfield, who did not live at the Phillips Mill, was friendly with William Lathrop and was instrumental in the development of the Bucks County School of Impressionism. He was regarded as "the dean" of the New Hope artists' colony but was very reclusive and often declined exhibiting his works with the school or mentoring its young artists. (Image courtesy of the New Hope Historical Society.)

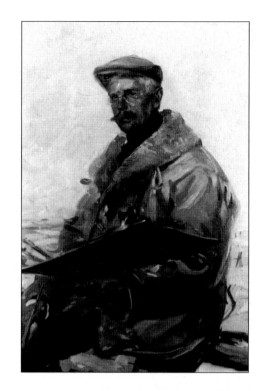

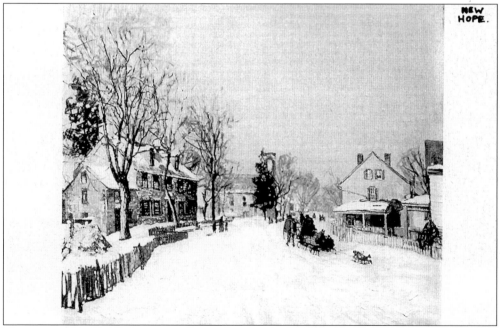

This is one of Redfield's famous *en plein air* (or "amidst nature") landscape snow scenes. Redfield would often brave the elements and paint in the worst of conditions, usually completing his work in just one sitting, without preliminary sketches. New Hope was a favorite landscape subject for Redfield. This is a painting of New Hope's Main Street on a snowy day. (Image courtesy of the Bucks County Historical Society.)

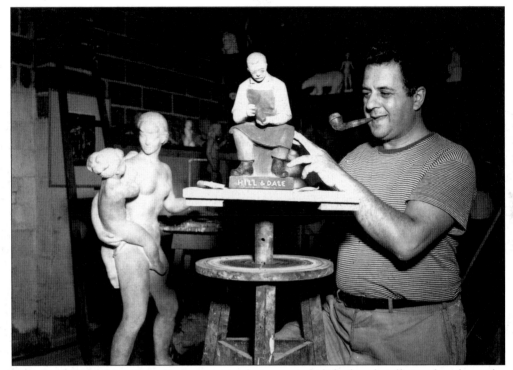

Born in Philadelphia, Harry Rosin came to be an accomplished and well-noted sculptor the world over. After traveling extensively around the globe, Rosin and his wife settled in New Hope. He is most famous for his sculptures of Tahitian women and children. Rosin's most recognizable work is the sculpture of Connie Mack that was once placed outside of Veterans Stadium in Philadelphia. (Images courtesy of the New Hope Historical Society.)

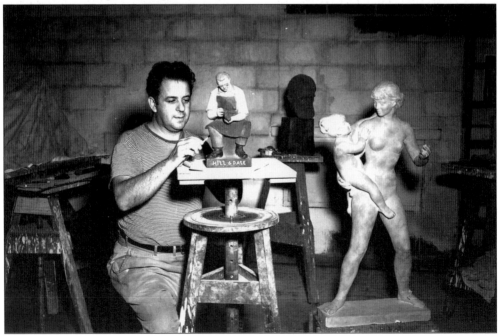

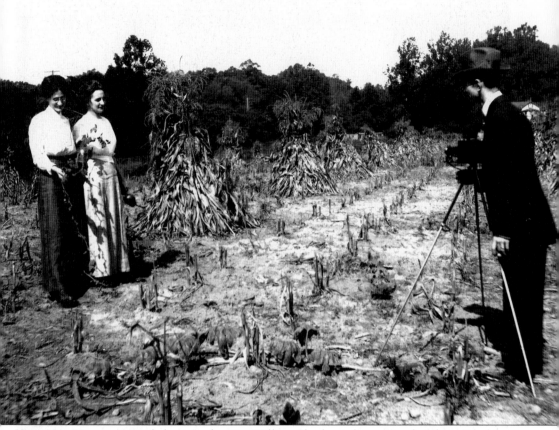

Here, New Hope artist and photographer Dr. William Sharkey is busy at work. Like most of the area's artists, he loved to work deep in the beautiful Bucks County landscape. As Sharkey was searching for a natural muse he happened upon another photographer shooting a portrait. In an instant, he clicked his shutter and captured "the process" from the outside. (Image courtesy of the New Hope Historical Society.)

These family photographs were also shot by Dr. William Sharkey in the early 1900s. Armed with his camera, Sharkey photographed much of New Hope and its surrounding region. Pictured here are unidentified families of the New Hope area. (Images courtesy of the New Hope Historical Society.)

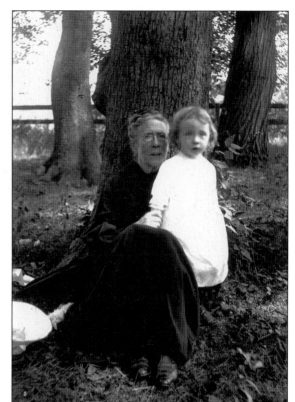

These two views are, once again, images from the camera of Dr. William Sharkey. His photographs, which have never been published before, offer onlookers a glimpse of Victorian-era life that is seldom seen. These images are more relaxed than the typical posed portraits of the Victorian period and thus offer a more realistic view of life for a New Hope working-class family. (Images courtesy of the New Hope Historical Society.)

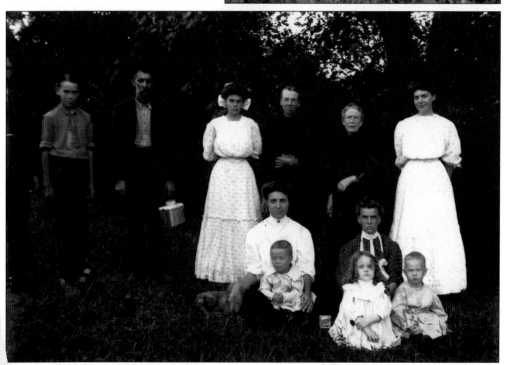

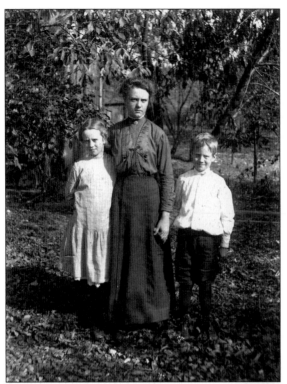

Dr. William Sharkey's photographic travelogue of New Hope continues. In these two portraits Sharkey captures two Victorian-era mothers with their children. They are so beautifully posed within their natural environments that viewers are given a sense of being able to step into the pictures themselves and talk with the women, feel the breeze blowing through, and hear the crunching of leaves beneath their feet. (Images courtesy of the New Hope Historical Society.)

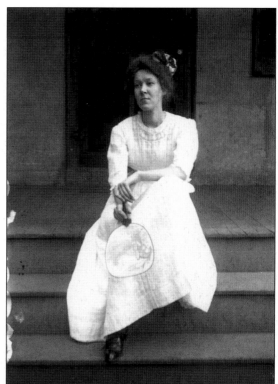

This is the last stop on Dr. William Sharkey's photographic tour of New Hope. In these images viewers are treated to portraits of a beautiful lass holding a fan and a stately looking gentleman. With a talented eye, through the lens of his camera Sharkey ably captured life in New Hope at the turn of the 20th century. (Images courtesy of the New Hope Historical Society.)

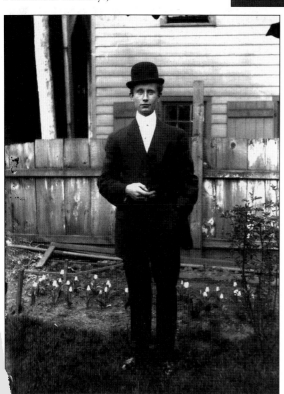

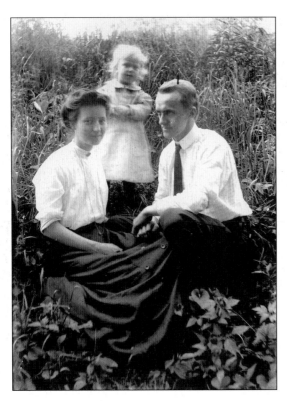

Families like this one have chosen to enjoy Bucks County and its beautiful landscapes as a destination for vacations or a relaxing local getaway. Couples, often seen with children in tow, find New Hope to be a family-friendly location. Innkeepers, restaurateurs, and shopkeepers have preserved the enticing allure of New Hope as a tourist hot spot for over a century. (Image courtesy of the New Hope Historical Society.)

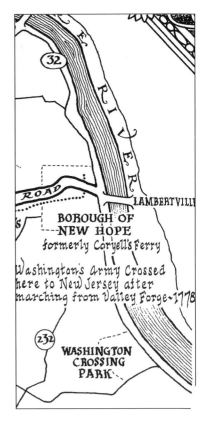

After a restful night's sleep, travelers could wake up and explore the pleasures of New Hope. They could discover the town's richness in culture and art, and its culinary delights. Many would choose to stay and build their lives here; others would continue on, making their way across the Delaware River and on to New York. (Map courtesy of the Old York Road Historical Society.)